Introduction to

Art Image Access
Issues, Tools, Standards, Strategies

Edited by Murtha Baca

Getty Research Institute

The Getty Research Institute Publications Program

Thomas Crow, *Director, Getty Research Institute*

Gail Feigenbaum, *Associate Director, Programs*

Julia Bloomfield, *Head, Publications Program*

Introduction to Art Image Access: Issues, Tools, Standards, Strategies

Beverly Godwin, *Manuscript Editor*

Michelle Bonnice, *Production Editor*

Elizabeth Zozom, *Production Coordinator*

Designed by Hespenheide Design, Westlake Village, California

Printed by Typecraft, Inc., Pasadena, California

Bound by Roswell Bookbinding, Phoenix, Arizona

Published by the Getty Research Institute, Los Angeles

Getty Publications

1200 Getty Center Drive, Suite 500

Los Angeles, CA 90049-1682

www.getty.edu

© 2002 The J. Paul Getty Trust

06 05 04 03 02 5 4 3 2 1

Cover images: See figure 17 (pp. 36–37)

Library of Congress Cataloging-in-Publication Data

Introduction to art image access : issues, tools, standards, strategies / edited by Murtha Baca

 p. cm.

Includes bibliographical references and index.

 ISBN 0-89236-666-4

 1. Cataloging of pictures. 2. Subject headings—Pictures. 3. Pictures—Computer network resources. 4. World Wide Web—Subject access. 5. Internet searching. I. Title: Art image access. II. Baca, Murtha.

Z695.718 .I67 2002

025.4'9—dc21

 2002002790

Contents

Introduction

The impetus for this book is the art information community's very real need for practical guidelines on how to lead end-users to relevant images of art and architecture online.

 The authors of the four chapters are professionals whose daily work and long-term research focus on providing access to art. Sara Shatford Layne gives a definition and overview of subject access to images of works of art and discusses related issues and solutions. Patricia Harpring addresses practical implementations of metadata schemas and controlled vocabularies, as well as specific problems and decisions that are part of building efficient, usable, and useful art information systems. Colum Hourihane stresses the key role played by those who analyze and index images of works of art, focusing on tools and methods for iconographic analysis and description. Christine Sundt discusses some of the major complexities of art information beyond and in combination with subject analysis, exploring the challenges faced both by searchers for art images and by those who wish to assist those searchers.

 Just as every viewer brings a distinctive perspective to the viewing of works of art, so each author brings his or her own expertise, experience, and opinions to bear in the individual essays in this book. My own perspective is that the informed use of appropriate metadata schemas and controlled vocabularies is essential for the creation of good art information systems. But I also know from experience that information systems and the methods of populating them must be kept both practical and as simple as possible if they are going to have any degree of success, or even be implemented at all. Individual institutions and projects must do what is practical and achievable with the resources available to them, always with the goal of serving their various user groups. In building information systems, projects and institutions should create a data structure in which information is atomized to the degree that it is compliant with relevant standards and will enable good end-user retrieval. When systems become overly complex, cataloguing becomes more difficult and inefficient, and

usability both for those who are populating the system and for those who are its intended users declines. Practical considerations should take precedence over theoretical analysis. Checklists, local authorities, and any other tools that can facilitate cataloguing and indexing should be used as much as possible. And the importance of training cannot be stressed enough.

The annotated list of tools, glossary, and selected bibliography in this volume are the result of a collaborative effort on the part of the authors and myself. We hope they provide both useful reference tools and a common language for discussing issues and strategies that provide access to images.

The images included in this book are taken, for the most part, from the collections of the J. Paul Getty Museum and reflect to a great degree our own research interests; therefore, visual examples of non-Western art are lacking. But the standards, tools, and methods we discuss can be used to describe any type of art, architecture, or material culture.

Finally, I would like to stress the human element in the work of describing and providing access to images of works of art. Information technology is an integral part of the way in which we work today, but without the art-historical knowledge, intelligence, and experience of art information professionals, it would be impossible to enable users to find the images they seek.

Murtha Baca

Subject Access to Art Images

Sara Shatford Layne
Head, Cataloging Division, Science and Engineering Library
University of California, Los Angeles

One of the most important means of enabling users to locate art images is subject access, but providing such access is a complex and sometimes messy process. To clarify the issues, I begin by exploring two questions: What is subject access? What is an art image? During this exploration, I hope to show how the answers to these questions can affect the ways in which the subjects of art images are analyzed and access is provided to them. Then, I look at the steps involved in analyzing subjects and providing access through them to art images. Finally, I summarize the decisions that need to be made when providing subject access to art images.

What is subject access? What is an art image? The answers to these questions may seem at first to be as simple as the questions themselves, but they become complex as one considers them in depth. Let us begin by considering subject access. Subject access is access to an art image by means of the subject of that image or, more precisely, the subject of the work or works of art that image represents. The questions then become: What is the subject of a work of art? How should that subject be described in order to provide access to it?

The Subject of a Work of Art

Perhaps the most obvious aspect of the subject of a work of art is what that work depicts, what it is *of.* Looking at Edward Sheriff Curtis's photograph *The Eclipse Dance* (fig. 1), one might say that it is *of* a dance, *of* people, and even, although very faintly, *of* a solar eclipse. Although it may be obvious, the *of* aspect of a work of art is not necessarily simple. People and objects may be the first kind of *of-ness* that comes to mind, but a work of art may also depict activities or events (as, for example, a dance or a solar eclipse), places, and times. It can be useful to consider these various kinds of *of-ness* when thinking about the subject of a work of art.

Furthermore, what a work of art is *of* may be described in a variety of ways. One way is to describe what the work of art is of in

Fig. 1. Edward Sheriff Curtis
(American, 1868–1952). *The
Eclipse Dance.* 1910–14,
gelatin silver print, 14.15 ×
20.3 cm (5⁹⁄₁₆ × 8 in.). J. Paul
Getty Museum, Los Angeles

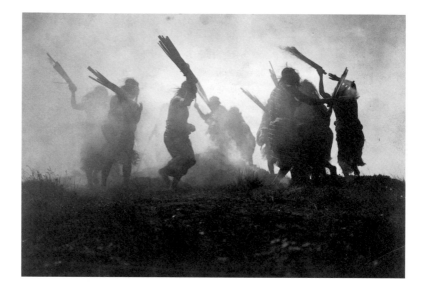

Fig. 1. Edward Sheriff Curtis
(American, 1868–1952). *The
Eclipse Dance.* 1910–14,
gelatin silver print, 14.15 ×
20.3 cm (5⁹⁄₁₆ × 8 in.). J. Paul
Getty Museum, Los Angeles

generic terms. In *Categories for the Description of Works of Art* (CDWA),[1]
this way is called Description, a subcategory under the category Subject
Matter. A second way is to give a specific name to what the work of art
is *of*—a subcategory called Identification under the category Subject
Matter in CDWA. Any one subject of a work of art can be described
with a range of terms, from the broadly generic to the highly specific.
For example, we can describe one of the subjects of Curtis's photograph
as "dance" or less broadly as "ceremonial dance," and we can also
identify it specifically as "Eclipse Dance." We see "people" who can be
identified as "Native Americans" (or, in Canada, "First Nations") but
who can also be identified more specifically as "Kwakuitl," and, if
information were available, could be still more specifically identified by
their personal names. As we can see, the range from generic to specific,
from description to identification, can be more of a continuum than a
dichotomy.

As another example, the subject of Frederick Henry Evans's
photograph *Across the West End of Nave, Wells Cathedral* (fig. 2) could be
described using terms such as "architecture," "religious buildings," "cathe-
drals," and "Wells Cathedral." Describing or identifying a particular sub-
ject at just one point in this range of terms will not necessarily meet the
needs of all searchers for an image. One can easily imagine a set of circum-
stances in which describing the subject of this last image as "religious
buildings" would best meet one searcher's needs, but a different set in
which describing the subject as "cathedrals" would meet another searcher's
needs. And, of course, one can imagine a third searcher who would best
be served by identifying the subject as "Wells Cathedral."

Although any subject, whether of a text or an image, can be described in both broad and narrow terms, images are different from text in that they are always *of* a specific instance of something. Unlike a text about religious buildings, an image cannot be a purely generic depiction of "religious buildings." An image must necessarily be, if not of a particular known and named building, at least of a particular type of building or construction. It may be a church or a monastery, a nave or a cloister, but it must be something more specific than "religious buildings." This characteristic of images makes it particularly important to provide access to a subject of an image at as many points as possible within the range of terms that can describe or identify that subject.

The three subjects I have just mentioned—"Eclipse Dance," "Kwakuitl," and "Wells Cathedral"—show that activities or events, persons, and objects can be described using a continuum of terms from the broadly generic to the relatively specific. It is useful to recognize that place and time can also be described in generic terms or identified with specific terms. For time, the difference between generic and specific is between description of cyclical time and identification of a chronological time, while for place it is the difference between description of a kind of space and identification of a geographic place. The place of Evans's photograph

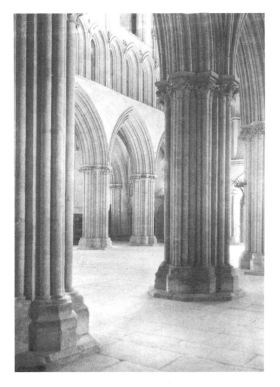

Fig. 2. Frederick Henry Evans (British, 1853–1943). *Across the West End of Nave, Wells Cathedral.* 1890–1903, platinum print, image: 15 × 10.5 cm (5⅞ × 4⅛ in.). J. Paul Getty Museum, Los Angeles

is the town of "Wells," in the county "Avon," in the country "England." Speaking descriptively or generically, the place of the photograph is "interior." The time of Curtis's photograph is "1910–1914"; it is also "daytime." If we knew more about the photograph we might be able to identify the season; it might be, for example, "spring" or "summer." It is easy to imagine circumstances in which a user would be interested in a generic description of a place depicted (for example, interiors of churches) or the identification of a particular place (for example, churches in England) or a combination of the two (interiors of churches in England).

Why is it useful to think about the different kinds of *of-ness?* It is useful because it gives us a checklist of the kinds of subject—persons, objects, activities, places, times—to consider when describing or assigning subject terms to art images. Thinking about the ways in which any single subject may be described or identified within a range of generic and specific terms gives us another checklist to use when identifying possible subjects; it may also affect the very structure of the information system providing user access. For example, it seems reasonable to assume that any image of "Wells Cathedral" is also an image of "cathedrals," an image of "religious buildings," and an image of "architecture." Rather than having to assign each of these terms to each image of Wells Cathedral, would it not be preferable to assign just the specific identifying term and have a system that inferred the generic descriptive terms from the specific identification? This is what the ICONCLASS system does in assigning higher-level terms for a specific description, as discussed by Colum Hourihane in his essay in this volume. But a local authority file could also be designed to carry the broader or more generic descriptive terms each time a specific term or set of terms is applied. Patricia Harpring discusses the creation of a subject authority in her essay in this volume.

Less obvious than the *of-ness* of a work of art, but often more intriguing, is what the work of art is *about,* which corresponds to the subcategory Interpretation under Subject Matter in CDWA. Sometimes the *about-ness* of a work of art is relatively clear, as in Georg Pencz's *Allegory of Justice* (fig. 3). This image is *of* a naked woman holding a sword and scales, but the title tells us that the image is an allegorical figure representing justice or, in other words, that the image is *about* the abstract concept "justice." In Goya's drawing *Contemptuous of the Insults* (fig. 4), the *about-ness* is slightly less obvious, but it is still clear that this work of art has some meaning beyond simply what it is *of.* Indeed, a description of what it is *of*—a man, perhaps Goya himself, gesturing toward two dwarfs wearing uniforms—is not really sufficient to make sense of this image; it symbolizes something else, it is *about* something else: the relationship between Spain and France at the beginning of the nineteenth century or, more specifically, Goya's personal attitude toward the French occupation of Spain.

Fig. 3. Georg Pencz (German, ca. 1500–50). *Allegory of Justice.* 1533, pen and brown ink over black chalk, 19.2 × 15 cm (7⁹⁄₁₆ × 5⁷⁄₈ in.). J. Paul Getty Museum, Los Angeles

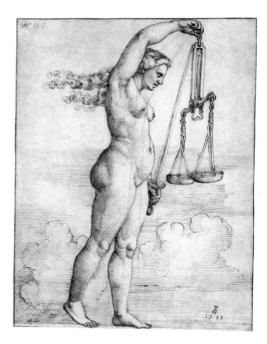

Fig. 4. Francisco José de Goya y Lucientes (Spanish, 1746–1828). *Contemptuous of the Insults.* 1803–12, brush and India ink, 29.5 × 18.2 cm (10¼ × 7³⁄₁₆ in.). J. Paul Getty Museum, Los Angeles

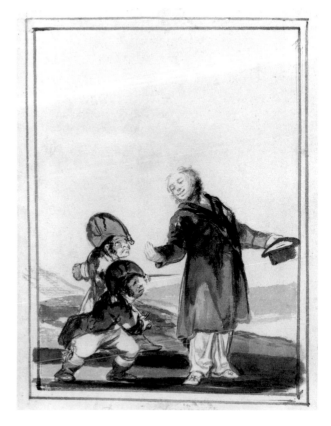

Let us look at a few more examples of ways in which both *of-ness* and *about-ness* are present in an art image. In a death scene by Gerard Horenbout (pl. 1) in a sixteenth-century Flemish book of hours, one part of the image depicts a person dying, while another part shows a decaying corpse on horseback, which symbolizes death. One could say that this work of art is both *of* death (the man in the bed is experiencing death) and *about* death (the corpse). In fact, this image is really *about* death in two different senses: the figure of the corpse personifies or symbolizes death, but the entire image or combination of scenes is *about* the omnipresence and inescapability of death.

The Destruction of Jerusalem (pl. 2) by the fifteenth-century Boucicaut Master reveals yet another kind of *about-ness*. In this image, which ostensibly depicts the siege of Jerusalem by the Romans in the first century, we see a somewhat stylized representation of a fifteenth-century French city, not a realistic depiction of first-century Jerusalem. Similarly, the people in the manuscript illumination appear to be fifteenth-century French people, not Romans from the first century or the civilian inhabitants of first-century Jerusalem. One could say that this work of art is *of* a fifteenth-century French city and *of* fifteenth-century French people, but it is *about* first-century Jerusalem and its inhabitants, *about* the Roman emperor Titus and his soldiers. Both the *of-ness* and the *about-ness* of this work of art could be of interest to users. It could be of interest to one researcher because of its depiction *of* a fifteenth-century city and to another because it is *about* Jerusalem. To still a third researcher, interested perhaps in what the scenery for a medieval European mystery play might have looked like, the fact that it depicts a fifteenth-century city as a representation of first-century Jerusalem would in itself be valuable.

The Birth of Esau and Jacob by the fourteenth-century Master of Jean de Mandeville (fig. 5) is similar to the previous example. This image depicts fourteenth-century European people, clothing, furnishings, and childbirth customs, but it is intended to represent an event that would have occurred several thousand years earlier on a different continent. In other words, it is *of* babies and midwives and baths and beds in medieval Europe, but it is *about* the biblical Esau and Jacob and their mother Rebecca.

In these last five examples, the works of art were, one might say, designed or intended as allegories or symbolic expressions, and their *about-ness* can perhaps be seen as an essential element of their subject analysis. But there are other works of art in which *about-ness* may be more tenuous, less clear, and perhaps even an unnecessary element of subject analysis. Consider the photographs by Evans and Curtis. Are these works of art *about* anything? Whether they are perceived as *about* something,

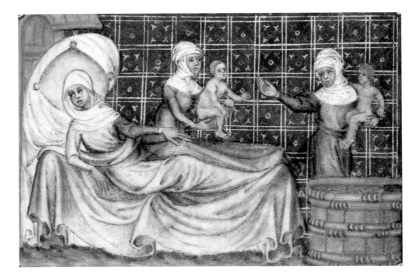

Fig. 5. Master of Jean de Mandeville (French, act. 1350–70). *The Birth of Esau and Jacob* from Peter Comestor, *Bible Historiale (Vol. 1)*, trans. Guiart des Moulins, MS 1, fol. 29v (detail). Ca. 1360–70, tempera colors, gold, and ink on parchment, leaf: 35 × 26 cm (13¾ × 10¼ in.). J. Paul Getty Museum, Los Angeles

and what they are perceived as being *about*, may depend to a great extent on the background of the person beholding the work of art. Is Evans's photograph *about* peace or timelessness or oppressive severity? Is Curtis's photograph *about* superstition or respect for nature? Is it *about* the human impulse to explain and control natural phenomena? When determination of *about-ness* requires highly subjective judgment, should that determination be included in providing subject access to art images? Should the inclusion of *about-ness* in subject analysis be limited to works of art that are clearly allegorical or symbolic in nature? These questions need to be considered when providing subject access to art images.

Why is it useful to identify the ways in which a work of art can be *of* or *about* a particular subject? It is useful because it leads us to consider the various aspects of the subject of a work of art, to which aspects it is worth providing access, and whether it is necessary to make distinctions between and among these various aspects. Is it necessary or useful to make a distinction between an image that is *about* death and one that is *of* death? Is it appropriate to provide access to *about-ness* that is highly subjective? If such access is provided, is it necessary or useful to make a distinction between an image that contains an allegorical or symbolic personification *of* death or justice and one that is *about* death or justice in a more subjective sense? Is it necessary or useful to make a distinction between historically accurate representations *of* Jerusalem and representations that are better described as being *about* Jerusalem? These questions also need to be considered when providing subject access to art images.

Some images, such as Horenbout's *Death Scene,* the Boucicaut Master's *The Destruction of Jerusalem,* and the Master of Jean de Mandeville's *The Birth of Esau and Jacob,* accompany, illustrate, or are in some way about literary works. *Death Scene* accompanies the Office of the Dead,[2] *The Destruction of Jerusalem* appears in the manuscript *Des cas des nobles hommes et femmes,*[3] and *The Birth of Esau and Jacob* prefaces the portion of the biblical Book of Genesis that describes that event. These literary works can be seen as another kind of description of the subject *of* the work of art, and therefore access to art images through the names of literary works may be considered, when appropriate, as providing an additional form of subject access.[4]

Although I am focusing on subject access to art images in this essay, I think it is useful to discuss briefly a category of access that is not, strictly speaking, subject access but is sometimes thought of in conjunction with, or even overlaps, subject access. This category of access, called Object/Work-Type in CDWA, describes not what the work of art is *of* or *about* but the kind of work that it *is.* The category Object/Work-Type can overlap with Subject for two reasons. The first is that, in some cases, the subject matter of an image can also be its Object/Work-Type. For example, "landscape" describes subject matter in the painting *Mythological Scene* by Dosso Dossi (pl. 3), although this image is, however, not a "landscape" in the Object/Work-Type sense. A painting from, say, the Barbizon School (a group of mid-nineteenth-century landscape painters) is both "a landscape" in the Object/Work-Type sense and depicts a "landscape" in the Subject sense.

The second reason that Object/Work-Type can overlap Subject is that, in the case of one work of art being depicted in another work, the term used to describe the Object/Work-Type of the depicted work becomes the term used to describe a Subject of the work in which it is depicted. In Evans's photograph of Wells Cathedral, "cathedral" is an Object/Work-Type of the depicted building, but since the photograph is *of* a cathedral, "cathedral" becomes a Subject of the photograph, not its Object/Work-Type; the Object/Work-Type of the artwork in hand is "photograph." Or, one might have an etching that depicts an artist at work in his studio surrounded by his paintings. Such an image would have "etching" as its Object/Work-Type, but "paintings" as a Subject. One searcher may want images that *depict* paintings; another searcher may want artworks that *are* paintings. Failing to distinguish between artworks that *are* paintings and artworks that depict (that is, are *of*) paintings diminishes the potential for precision in retrieval: searchers looking for just those images that are *of* paintings or just those artworks that *are* paintings will not be able to specify or retrieve only those images they want.

What Is an Art Image?

The foregoing discussion of works of art depicted in other works of art returns us to the big question: What is an art image? An art image may *be* a work of art; it may be an image *of* a work of art; or it may be both a work of art *and* an image of a work of art.[5] Pencz's *Allegory of Justice* represents an image—a drawing—that *is* a work of art; *Sarcophagus with Lid* (fig. 6) is an image—a photograph—*of* a work of art—in this case, a marble sarcophagus. The image itself—the photograph—is not a work of art, although it depicts a work of art—the sarcophagus. The image that is Evans's photograph *Across the West End of Nave, Wells Cathedral* is *itself* a work of art and in addition *depicts* the work of art that is Wells Cathedral. It is both a work of art *and* an image of a work of art. Curtis's photograph *The Eclipse Dance* is itself a work of art, but it is also an image of masks that can be considered to be works of art in their own right. Although the details of the masks cannot be seen in this image, the image does give useful information regarding these masks, as it shows them in the context of their use. An image that gives context to a work of art can be as valuable as an image that depicts the work more clearly—such as a photograph of a mask in a museum's collection that shows every detail precisely—but lacks context.

Fig. 6. Attic Workshop. *Sarcophagus with Lid* (front), ca. 180–220, marble, body: 134 × 211 × 147 cm (53 × 83¹/₁₆ × 58 in.); lid: 100 × 218 × 95 cm (39½ × 86 × 37½ in.). J. Paul Getty Museum, Malibu, California

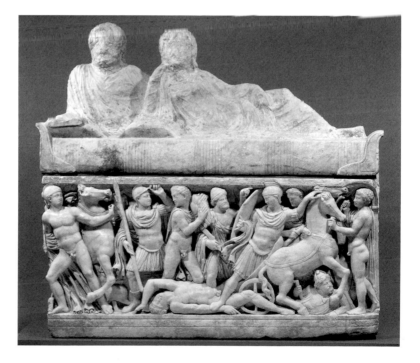

Why is it important to note that an art image may be not only a work of art itself but also an image of another work of art? First, the name of a given work of art (for example, *Wells Cathedral*) or a term that describes the type of work (for example, "masks") may become, as we have seen, subject terms when that work is depicted or represented in another work of art. It can be useful to consider whether one wishes to distinguish between artworks that are depicted in other artworks and those same artworks depicted in images that are not themselves generally regarded as works of art. For example, in providing access to images of Wells Cathedral, would one wish to try to distinguish between Evans's "artistic" photograph and photographs taken merely to document what the cathedral looks like? It seems doubtful that one would wish to make this distinction, although one would, of course, wish to provide access to Evans's photograph itself as a work of art. And if one does not wish to make this distinction, then the terminology and format of the access provided should be the same, whether the image that represents the work of art in question is simply recording that work or is a work of art in itself.

The situation in which a single term can describe Object/Work-Type in one context and Subject in another context can be generalized as follows: the same term can, in certain circumstances, describe or identify different aspects of works of art. For instance, "Goya" can identify a specific subject of a work of art, and "Goya" can also identify the creator of a work of art. In the case of *Contemptuous of the Insults,* "Goya" is both Subject and Creator of the work of art. One can easily imagine that a person seeking images *of* Goya would like to have them separated from works of art created *by* Goya; however, someone seeking works *by* Goya might be very pleased to be made aware of images that are *of* Goya. The point is that it may be useful to employ the same vocabulary to describe a person or object, whatever the role of that person or object vis-à-vis the art image may be, but it is at the same time necessary to provide a means for organizing such a retrieval based on metadata elements or categories of access.[6] Using consistent vocabulary promotes recall of relevant images; providing the means for organizing the retrieval based on category promotes precision. Categories can be differentiated from one another by placing them in different fields in a database record or otherwise identifying them as different metadata elements.

A second reason for pointing out that an art image may contain representations of works within works is that it may be desirable to provide subject access to each separate work of art represented by a single image and to associate the subject access for a particular work with *just* that work—not with a work that it represents or in which it is represented. Consider *Sarcophagus with Lid.* The sarcophagus can be considered the Subject of the photograph, but it is also the Object/Work-Type of the

work of art represented. Depicted in the photograph is the side of the sarcophagus that represents an event from the Trojan War: Hektor's body being dragged behind Achilles' chariot. But the sarcophagus is decorated with subjects not shown in this particular photograph, so that "Odysseus," depicted on an unshown end, is a Subject of the sarcophagus but not of this specific image of it. It may be desirable to provide access to all the subjects of the sarcophagus, while making it clear which of these subjects is actually depicted in this particular image of the sarcophagus. The desire to provide thorough access to the subjects of a work of art, yet identifying which subjects are actually depicted in a given image of that work of art, can influence the choice of a structure or metadata schema for providing subject access to art images. The *VRA Core Categories, Version 3.0,* provides a category—Record Type—that "identifies the record as being either a Work record, for the physical or created object, or an Image record, for the visual surrogates of such objects."[7] Identifying records in this way could make it possible to distinguish between the subjects of a work of art and the subjects of an image of that work.

Providing Subject Access to Art Images

Next I discuss the four steps necessary to provide access to art images through these subjects. Although these steps are listed separately and sequentially, they are not independent of one another or even performed in the order listed here. Choices made in one step influence the choices made in another. In the first step, decisions are to be made regarding which of the subject aspects discussed above should be used in providing access to the art images, whether and which distinctions will be made between and among these various aspects, and what the depth of the subject analysis should be. In the second step, someone or something must be identified to provide the analysis of the subjects of the image. In the third step, vocabulary and a metadata structure or format for recording that analysis must be selected. In the fourth step, an information system must be chosen or developed for providing access to the subjects that have been analyzed and recorded.

Subject Aspect Decisions

How does one decide which subject aspects of art images should be used to provide access to them? Although available resources are always a factor in such a decision, the major factor should be what kinds of access are most useful. Unfortunately, it is very difficult to design research to assess accurately the usefulness of different kinds of access. Usefulness will inevitably depend on who needs the access, as well as on the nature of the art image.

Some researchers have analyzed queries made of large picture or stock-shot files, queries made chiefly in support of illustration or commerce.[8] The items were not, for the most part, art images, and the purpose of the queries was generally not the support of research. The results showed that the queries tended to be satisfied by an analysis of what an image is *of,* not by what an image is *about.* My research suggests, however, that *about-ness* is a determinant of relevance of art images in approximately 20 percent of art history research.[9] This means that approximately 20 percent of art history research might benefit from providing access by what a work of art is *about.*

I also found that *of-ness* was a determinant of relevance of art images in approximately 35 percent of art history research, suggesting that providing access by the *of-ness* of an art image would be even more useful than providing access by its *about-ness.* In addition, Lucinda Keister suggested, because *about-ness* is subjective and someone interested in the *about-ness* of an image can generally specify certain *of-ness* subjects that it should contain, it is more useful to provide access by the *of-ness* of the image. Then the researcher can browse through a retrieved group of images and make his or her own determination of *about-ness.*[10] In support of the position that *about-ness* can be at least partly defined by *of-ness,* Layne's analysis of research in art history suggests that in approximately half the cases in which *about-ness* was a determinant of relevance, *of-ness* was also a determinant.[11] It might be possible to choose to index the *about-ness* of art images that are clearly personifications or symbols, as for example "justice" for Pencz's *Allegory of Justice,* "Spain—Relations—France" for Goya's *Contemptuous of the Insults,* "death" for Horenbout's *Death Scene,* and "Jerusalem" for *The Destruction of Jerusalem,* but not to index it for more tenuous and subjective instances, such as Curtis's *The Eclipse Dance.*

With regard to the usefulness of another form of subject access discussed earlier, namely, the literary work that an image is *about,* Layne's analysis of research in art history suggests that such literary works are determinants of relevance for approximately 15 percent of art history research. This relatively small percentage may be more an indication of the percentage of works of art that are about literary works than an indication that it is of limited usefulness when providing access. Indeed, I would say that whenever a work of art is about a literary work, it would be useful to provide access through the name of that literary work.[12]

Once it has been decided to index different kinds of subjects, as for example *of-ness* and *about-ness,* how does one decide whether the distinctions between or among these different kinds should be preserved and codified for use in providing access? The disadvantage of codifying distinctions is that a considerable amount of time and effort would be required, and different people can come to different conclusions about borderline

cases. For example, is *The Birth of Esau and Jacob* an image of "childbirth," interpreting "childbirth" broadly as the activities that surround that event, or is it really *about* "childbirth," since the actual emergence of a child into this world is not depicted? Yet, there are advantages to codifying distinctions. As mentioned earlier in a slightly different context, codifying distinctions increases precision in retrieval, as it makes it possible to retrieve, for example, just those images that are *of* "death" and to exclude those images that are *about* "death." It also permits the subdivision of large sets of retrieved images based on these distinctions. For example, a search on "death" as a subject could result in a retrieval of images subdivided into groups based on whether the image explicitly depicts "death" or is *about* the theme of "death."

There is still a decision to be made with respect to the depth of subject analysis. Some images, for example *The Destruction of Jerusalem* and *Death Scene,* are particularly rich in the number of people, objects, and activities depicted. Other images, such as *The Eclipse Dance,* may show people, objects, and activities, but not very distinctly or clearly. In images such as these, does one provide subject access to every single person, object, and activity depicted? Stated another way, how does one make decisions regarding the depth of indexing? An image indexing project for the Bibliothèque Nationale in Paris, now more than twenty years old, developed guidelines that still seem valid today: index anything that is clearly depicted; also index anything that is not clearly depicted if the mere fact of its presence in the image is informative; do not index parts of a whole if the whole is indexed and the parts are implicit in it.[13]

Let us look at how these recommendations regarding depth of indexing might affect the subject analysis of a couple of art images. For *Allegory of Justice,* it might mean that "naked woman" would be indexed, as well as "sword" and "scales," but not "face" or "breast" or "arm" or "leg," as those body parts are implicit in "naked woman." For *The Eclipse Dance,* it might mean that "masks" would be indexed, although they are not distinctly depicted, as their mere presence in the image is of interest. The goals or focus of a particular institution can also affect depth of indexing. An institution focusing on architecture might, for example, want to provide more detailed indexing for Evans's *Across the West End of Nave, Wells Cathedral,* than would an institution focusing on the history of photography.

It may not, however, be necessary or even desirable to index at a level of detail that narrows retrieval to a very few images. Browsing through a set of possibly relevant images may be a better way for a searcher to identify desired images than a highly specific search.[14] For the art historian, for whom comparison is an essential method of research,[15] providing a larger set of possibly relevant images may lead to connections and

comparisons that otherwise might not have been made. In addition, practical factors—including time, money, and the knowledge and skills of the staff performing the subject analysis—affect the depth of subject indexing possible for a particular collection.

Performance of Subject Analysis

Who or what performs the analysis of the subject in a work of art? For some years there has been strong interest in automated analysis of images, and there have been various attempts to use pattern recognition techniques and iterative methods to identify and retrieve relevant images. To date, none of these efforts has been particularly successful in retrieving images from heterogeneous groups or in identifying objects, such as horses, that can be depicted in a variety of poses, from many different angles, and under various lighting conditions.[16] Automated systems are most successful in analyzing homogeneous sets of images and in selecting images based purely on color, composition, and texture. Such elements are relatively easy to codify and therefore relatively easy for a computer to identify.[17] With what appears to be significant effort, some systems have had some success in identifying image types such as landscapes that tend to have certain common compositional and color characteristics.[18] But it is safe to say that content-based—that is, automated—image retrieval is still far from being even remotely useful to art historians or art researchers.

A key to the possibly intractable problems involved in attempting to substitute computer analysis for human analysis may be found in an unlikely source: an article by the neurologist Oliver Sacks concerning the problems encountered by a man, blind almost from birth, whose physical ability to see was restored to him when he was middle-aged.[19] This man was unable to "see" properly, unable to distinguish, for example, his black-and-white dog from his black-and-white cat. Sacks postulates that this difficulty occurred because the process by which humans learn to interpret what their eyes see is a complex one that takes place as the brain develops during childhood and involves senses other than sight.

Subject analysis by humans is expensive and time-consuming, however, and studies have suggested that human indexers are not necessarily consistent in their analysis of subjects.[20] There are, however, various methods by which consistency among humans can be promoted, including the use of controlled vocabularies, guidelines for subject analysis, and even checklists or picklists of possible subject aspects. The ideal at this time would seem to be to let humans do what they do best and to let computers do what they do best. In other words, let humans identify the subjects of an art image and let computers identify color, shape, and composition. For example, if human indexers were to identify the subjects of art images, a computer could, if desired, then analyze a large retrieved

set of images with the same subject (for example, "cathedrals," "dance," "sarcophagi") for similarities in shape, color, or composition.[21]

Choice of Vocabularies and Format

To provide efficient, accurate subject access to images, vocabularies and a metadata format must be selected, and decisions must be made regarding the depth of the subject analysis.

The generally acknowledged advantages of controlled vocabularies have been discussed elsewhere,[22] and the specific vocabularies that may be most appropriate for subject access to art images are discussed in the other essays in this publication. There are, however, three aspects of subject access that are particularly important to vocabulary choice for art images and should be kept in mind when deciding on vocabularies for providing access to art images. The first aspect, discussed earlier, is that an image *of* something is always of a particular instance of that something (for example, "Wells Cathedral"), although it may be sought because it is an image *of* something that can be described more broadly or generically (for example, "religious architecture" or "cathedrals"). Regarding vocabulary choice, this means that to avoid indexing each subject of each image with every possible broader term for that subject, it is important to have a vocabulary with a syndetic structure that provides good links from the broadest to the narrowest terms, links that lead from the generic to the specific. This is why thesauri, which have an explicit syndetic structure, are increasingly popular in projects that attempt to provide good user access to visual materials.

The second aspect of vocabulary choice for art images is that any given image may be of interest to different disciplines with different vocabularies. For example, *The Birth of Esau and Jacob* might be of interest to historians of medicine who might wish to use a medical vocabulary, rather than a more general vocabulary, when searching for images. Clearly, it is not practical to use all possible vocabularies when providing subject access to art images, but if it is known or intended that a particular collection of art images will be used by a particular discipline, it may be worth considering the use of a specialized vocabulary in addition to a general vocabulary. For example, an image of tulips might be indexed as "tulips" or even "flowers" for general users, but scientific species names such as *Tulipa turkestanica* might be used as indexing terms if botanists are among the intended users.

The third crucial aspect of vocabulary choice for art images is, as discussed earlier, that the same term can describe or identify different metadata categories or access points for works of art. "Goya," for example, can identify a Creator or a Subject of a work of art or, in some cases, both. The terms "painting" or "landscape" can describe an Object/Work-Type or

a Subject, as we have seen above. If different vocabularies are chosen for each metadata category, the terms could be slightly different, depending on the category of access, and this may not be desirable. So in choosing a vocabulary for subject access it is important to coordinate this selection with the choices of vocabulary for other categories of access in the same information system.

The advantages and disadvantages of various formats for describing art images are discussed elsewhere in this book, as are specific vocabularies and classification systems. There are, however, two previously discussed aspects of the subjects of art images that affect the choice of format for providing access to these subjects. The first aspect is that different kinds of subjects may exist in an image, which means that there is the possibility of distinguishing among them. If there is a desire to distinguish, for example, between subjects that describe the *about-ness* of an art image and those that describe or identify its *of-ness,* then the chosen format needs to support that distinction. The second aspect is that a single image may represent more than one work of art. In this situation there may be a need to associate subjects with the appropriate work of art, and the format used to describe the art image would have to make this association possible. As mentioned earlier, the *VRA Core Categories* permits the distinction between *work* and *image.* Conceivably, this distinction could be used to associate one set of subjects with, for example, Wells Cathedral, and another set of subjects with Evans's photograph of that cathedral.

Choice and Design of a System

The fourth step is the selection or design of an information system for retrieving and displaying art images. What I mean here by "information system" is software that stores, indexes, retrieves, and displays records, and ideally, the images that these records describe.

What should a good information system do with respect to subject access to art images? It should take thorough advantage of the syndetic structure of vocabularies to permit retrieval at varying levels or degrees of specificity and to promote refinement of searches, broadening or narrowing them as a searcher may require. A searcher looking for images of "dances" should be able to retrieve the image *The Eclipse Dance* and should also be able to refine the search so that it is limited to images of "ceremonial dances." A searcher looking for images of Wells Cathedral should be able to refine the search, broadening it to include "cathedrals" or "cathedrals in England."

A good information system should be able to take advantage of distinctions among kinds of subjects and between subject and other categories of access, always assuming that these distinctions are present in the metadata schema or format that has been chosen to describe the images,

but ideally without forcing the searcher to be aware of these distinctions in advance. Although the information system should recognize the distinction between the Creator and Subject categories of access, or between Subject and Object/Work-Type, it should permit the searcher who has employed a search term common to both categories to be made aware of that term's use in both categories while still preserving the distinction between the categories. For example, consider a menu-based information system in which the user of the system is given a list of categories of access from which to choose, categories such as Title, Object/Work-Type, and Subject. In such a system it might be more useful to provide the user with the selection "Persons" (which would include persons as subjects, as well as creators) rather than "Creators." Once the search is performed, the results could be grouped by the role the person had vis-à-vis a particular work of art: creator, subject, owner, and so on. In a system offering a search on "Persons," a search on "Goya" would retrieve both works by Goya and works of which he was a subject, but the results of the search would be presented as two separate groups, enabling the searcher to select either group or both. In a system offering instead Creator and Subject as separate choices, the searcher must first decide into which category "Goya" fits, and if Creator is chosen, the searcher may remain unaware of images of which "Goya" is a subject.

Regarding the display of images retrieved by a search, a good system should make it possible to view several images at the same time and to browse among retrieved sets of images. Ideally, the searcher should be able to rearrange retrieved images to enhance comparisons among images. As I mentioned earlier, comparison is an essential element of art history research. Ideally, the searcher should also be able to refine or reorganize retrieved images based on characteristics other than subject, and analyses of some of these characteristics, in particular color, composition, and texture, could be performed by the system itself at the time of need.

Conclusion

Let us review, in the form of questions to be answered, the decisions to be made when providing subject access to art images.

- Having considered the various kinds of subjects—*of, about* (or levels of description, identification, and interpretation), and literary works that an art image can be *about*—through which of them will you provide access?
- If you are providing access to more than one kind of subject, do you want to codify the distinctions between or among them?
- What level of analysis, or what depth of indexing, do you want to provide?

- What vocabularies will you use to record your subject analysis?
- What metadata schema or format will you use to describe art images?
- What type of information system will you use to retrieve and display the art images?

I hope that this essay, together with the others in this volume, provides the conceptual framework and information necessary to answer these questions in ways that improve subject access to art images.

Notes

1. *Categories for the Description of Works of Art* (CDWA), <http://www.getty.edu/research/institute/standards/cdwa>, a metadata schema for art objects and their visual surrogates, outlines many metadata categories of which Subject Matter is one. The Subject Matter category is subdivided into Description, Identification, and Interpretation. In her essay in this volume, Patricia Harpring uses CDWA as the metadata framework for cataloguing or indexing art images. For a fuller discussion of the many aspects of the subject of an image, see Sara Shatford, "Analyzing the Subject of a Picture: A Theoretical Approach," *Cataloging and Classification Quarterly* 6, no. 3 (1986): 39–62.

2. A devotional service for the dead in the Roman Catholic liturgy, the Office of the Dead is often included in books of hours.

3. An early fifteenth-century French translation of Giovanni Boccaccio's *De casibus virorum illustrium,* a fourteenth-century collection of stories about exemplary heroes and heroines from biblical, classical, and medieval history.

4. An example of providing access to images through related textual works is the Princeton Index of Christian Art, which has for some time provided citations to the biblical passages that are the source for many of its images.

5. Strictly speaking, one can say that any image that is not the physical original—that is, any image that reproduces a work of art—is an image or visual surrogate of that work. Useful as this concept of a reproduction is when describing the non-subject attributes of a reproduction (for example, it permits description of the medium of the reproduction as distinct from the medium of the original), it is of limited usefulness when providing subject access. For further reading, see Sara Shatford, "Describing a Picture: A Thousand Words Are Seldom Cost Effective," *Cataloging and Classification Quarterly* 4, no. 4 (1984): 13–30.

6. See the glossary entry for *access point.*

7. *VRA Core Categories, Version 3.0,* <http://www.vraweb.org/vracore3.htm>.

8. See for example, P. G. B. Enser, "Query Analysis in a Visual Information Retrieval Context," *Journal of Document and Text Management* 1, no. 1 (1993):

25–62; and also James Turner, "Representing and Accessing Information in the Stock-Shot Database of the National Film Board of Canada," *Canadian Journal of Information Science* 15, no. 4 (1990): 1–22.

9. Sara Shatford Layne, *Modelling Relevance in Art History: Identifying Attributes that Determine the Relevance of Art Works, Images, and Primary Text to Art History Research* (Ann Arbor, Mich.: University Microfilms, 1998), 235.

10. Lucinda Keister, "User Types and Queries: Impact on Image Access Systems," in Raya Fidel et al., *Challenges in Indexing Electronic Text and Images* (Medford, N.J.: published for the American Society for Information Science by Learned Information, 1994), 7–22.

11. Layne, *Modelling Relevance in Art History,* 235–36.

12. Layne, *Modelling Relevance in Art History,* 242.

13. Maxime Préaud and Michel Rio, "Images sans histoire: Méthode de description des images et classement informatique," in Paola Barocchi, Fabio Bisogni, and Laura Corti, eds., *First International Conference on Automatic Processing of Art History Data and Documents, Pisa, Scuola Normale Superiore, 4–7 September 1978: Conference Transactions* (n.p.: n.p., [1978]), 2:256.

14. See Christine Sundt's essay in this volume, note 5.

15. Richard Brilliant, "How an Art Historian Connects Art Objects and Information," *Library Trends* 37, no. 2 (1988): 120–29.

16. B. Holt and L. Hartwick, "Retrieving Images by Image Content, the UC Davis QBIC Project," *Aslib Proceedings* 46, no. 10 (1994): 243–48.

17. R. Rickman and J. Stonham, "Similarity Retrieval from Image Databases — Neural Networks Can Deliver," in *Storage and Retrieval for Image and Video Databases, 2–3 February 1993, San Jose, California,* Proceedings of SPIE, vol. 1908 (Bellingham, Wash.: SPIE, 1993), 85–94.

18. See, for example, D. A. Forsyth, "Computer Vision Tools for Finding Images and Video Sequences," *Library Trends* 48, no. 2 (1999): 326–55.

19. Oliver Sacks, "To See or Not to See: A Neurologist's Notebook," *New Yorker,* 10 May 1993, 59–73.

20. Karen Markey, *Subject Access to Visual Resources Collections: A Model for Computer Construction of Thematic Catalogs* (New York: Greenwood, 1986), 61–66.

21. A prototype system of this sort is described in Yong Rui et al., "Information Retrieval Beyond the Text Document," *Library Trends* 48, no. 2 (1999): 455–74.

22. See, for example, R. G. Henzler, "Free or Controlled Vocabularies," *International Classification* 5, no. 1 (1978): 21–28.

The Language of Images: Enhancing Access to Images by Applying Metadata Schemas and Structured Vocabularies

Patricia Harpring
Managing Editor, Getty Vocabulary Program
Getty Research Institute

The appetite of end-users, hungry for images, is rarely sated. Images are notoriously difficult to retrieve with accuracy, as is evident to anyone who has searched for images on the World Wide Web. Retrieval of appropriate images depends on intelligent indexing, which one might call the "language" of retrieval; in turn, good indexing depends on proper methodology and suitable terminology. In this essay, I address the underpinnings of indexing by exploring the use of metadata schemas[1] and controlled vocabularies to describe, catalogue, and index works of art and architecture, and images of them. I also discuss issues relating to data structure, cataloguing rules, vocabulary control, and retrieval strategies, which are central components of good subject access.

What Is "Subject"?

Categories for the Description of Works of Art (CDWA) characterizes "subject" very broadly as follows:

> The subject matter of a work of art (sometimes referred to as its content) is the narrative, iconic, or non-objective meaning conveyed by an abstract or a figurative composition. It is what is depicted in and by a work of art. It also covers the function of an object or architecture that otherwise has no narrative content.

CDWA describes a metadata element set that can be used to describe or catalogue many types of objects and works of architecture in a single information system. In the interest of providing access across all catalogued objects by all of the critical fields (the "core" categories), CDWA advises that the Subject Matter category should *always* be indexed, even when the object seems to have no "subject" in the traditional sense. In other words, in CDWA all works of art and architecture have subject matter.

Even though the subject matter of a work of art may also be referred to in the Titles or Names category of CDWA, a thorough descrip-

tion and indexing of the subject content should be done separately in the Subject Matter category. A title does not always describe the subject of the work. More importantly, noting the subject of a work of art in a set of fields or metadata elements dedicated specifically to subject ensures that the subject is consistently recorded and indexed in the same place, using the same conventions for all objects in the database. The title of the photograph in figure 7, *Chez Mondrian, Paris,* does not convey a basic description of the subject of the photograph. Its subject could be described as "an interior space with a stairway, doorway, table, and a vase with flowers."

The subject matter of a work may be narrative, but other types of subjects may also be included. A narrative subject is one that comprises a story or sequence of events. Examples of narrative subjects are *The Slaying of the Nemean Lion* and *The Capture of the Wild Boar of Mount Erymanthus,* which are both episodes in the *Labors of Herakles* series. Subject matter that does not tell a story could be, for example, a painting or sculpture of a genre scene, such as a young woman bathing. For a portrait, the subject can be a named sitter; for a sketch, an elevation for the facade of a building; for a pot or other vessel, its geometric decoration or

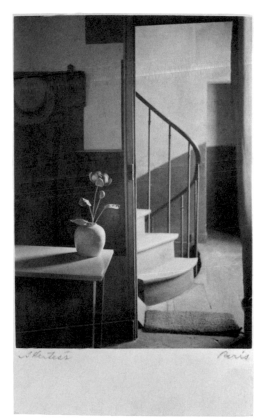

Fig. 7. André Kertész (American, born Hungary, 1894–1985). *Chez Mondrian, Paris.* 1926, gelatin silver print, 10.9 × 7.9 cm (4⁵⁄₁₆ × 3⅛ in.). J. Paul Getty Museum, Los Angeles

its function; for a mosque or synagogue, its function as a place of worship. Subject matter can also take the form of implied themes or attributes that come to light through interpretation. For example, a brass doorknob with an embossed lion's head can express meaning beyond the depiction of an animal; it may suggest the householder's strength or confer protection on the house.

In a scholarly discussion of subject matter, various areas of subject analysis are often woven together into a seamless whole. It is useful, however, to consider them separately when indexing a work of art. One level of subject analysis could include an objective description of what is depicted; for example, in the Sodoma drawing in figure 8, the words "human male," "nude," "drapery" describe the image in general terms. An identification of the subject would be "resurrected Christ." The image could be further analyzed, noting that the iconography represents "salvation" and "rebirth."

Fig. 8. Sodoma (Italian, 1477–1549). *The Resurrection.* Ca. 1535, pen and brown ink and black chalk, heightened with white bodycolor, on brown paper, 21.5 × 18.7 cm (8⁷⁄₁₆ × 7³⁄₈ in.). J. Paul Getty Museum, Los Angeles

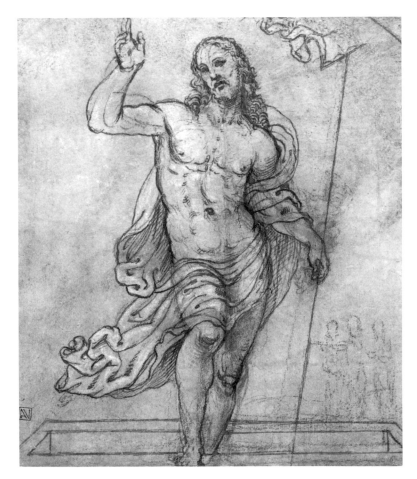

In CDWA, subject matter is analyzed according to a method based on the work of Erwin Panofsky.[2] Panofsky identified three main levels of meaning in art: pre-iconographic *description,* iconographic *identification,* and iconographic *interpretation* or "iconology." Three sets of sub-categories under the category Subject Matter in CDWA reflect this traditional art-historical approach to subject analysis, but in a somewhat simplified and more practical application of the principles, one better suited to indexing subject matter for purposes of retrieval. (Panofsky was writing decades before the advent of computer databases of art-historical information and the proliferation of resources on the World Wide Web.) The following three levels of subject analysis are defined in CDWA:

> *Subject Matter—Description.* A description of the work in terms of the generic elements of the image or images depicted in, on, or by it.
>
> *Subject Matter—Identification.* The name of the subject depicted in or on a work of art: its iconography. Iconography is the named mythological, fictional, religious, or historical narrative subject matter of a work of art, or its non-narrative content in the form of persons, places, or things.
>
> *Subject Matter —Interpretation.* The meaning or theme represented by the subject matter or iconography of a work of art.

These three levels of subject analysis can be illustrated in Andrea Mantegna's *Adoration of the Magi* (pl. 4). A generic *description* of Mantegna's painting would point out the elements recognizable to any viewer, regardless of his or her level of expertise or knowledge: it depicts "a woman holding a baby, with a man located behind her, and three men located in front of her." Possible indexing terms to describe the scene could be "woman," "baby," "men," "vessels," "porcelain vessel," "coins," "metal vessel," "costumes," "turbans," "hats," "drapery," "fur," "brocade," "haloes." The next level of subject analysis is *identification,* which is often the only level of access cataloguing institutions routinely provide. The painting depicts a known iconographic subject that is recognizable to someone familiar with the tradition of Western art history: "Adoration of the Magi." The iconography is based on the story recounted in the New Testament (Matthew 2), with embellishments from other sources. The proper names of the protagonists are Balthasar, Melchior, Caspar, Mary, Jesus, and Joseph; these names should also be listed as part of the identifiable subject.

The third level of subject analysis is *interpretation,* where the symbolic meaning of the iconography is discussed. For example, the Magi represent the Three Ages of Man (Youth, Middle Age, Old Age), the Three Races of Man, and the Three Parts of the World (as known in the fifteenth century: Europe, Africa, Asia). The gifts of the Magi are symbolic of

Christ's kingship (gold), divinity (frankincense), and death (myrrh, an embalming spice). The older Magus kneels and has removed his crown, representing the divine child's supremacy over earthly royalty. The journey of the Magi symbolizes conversion to Christianity. Details related to the subject, as depicted specifically in this painting, could include Mantegna's composition of figures and objects, all compressed within a shallow space in imitation of ancient Roman reliefs.

Even when a work of art or architecture has no overt figurative or narrative content, as with abstract art, architecture, or decorative arts, subject matter should still be indexed in the appropriate metadata element or database field. In the case of a work of abstract art, John M. Miller's *Prophecy* (fig. 9), visual elements of the composition can be listed, including the following: "abstract," "lines," "space," "diagonal." The symbolic meaning, as stated by the artist, should also be included. In this case, the artist's work was inspired by a fifteenth-century prayer book.[3] This aspect of the subject could be listed as follows: "Jean Fouquet," "Hours of Simon de Varie," "Madonna and child," "patron," "kneeling," "inward reflection," "moment in flux."

It may seem something of a stretch to designate subject matter for decorative arts and architecture, where no recognizable figure or symbolic interpretation is possible. For the sake of consistency, however, and always keeping end-user retrieval in mind, it is useful to note subject matter for these types of objects as well. The subject of a carpet, such as the one shown in figure 10, could be design elements and symbols of the patron for whom it was made, such as "flowers," "fruit," "acanthus leaf scrolls," "sunflower," "Sun King," "Louis XIV." The subject of a

Fig. 9. John M. Miller
(American, b. 1939).
Prophecy. 1999, acrylic resin
on canvas, 228.6 × 350.5 cm
(90 × 138 in.). J. Paul Getty
Museum, Los Angeles

Fig. 10. Savonnerie Manufactory (French, act. 1627–present). *Carpet.* Ca. 1666, wool and linen, 670.6 × 440.1 cm (22 ft. × 14 ft. 5¼ in.). J. Paul Getty Museum, Los Angeles; Gift of J. Paul Getty

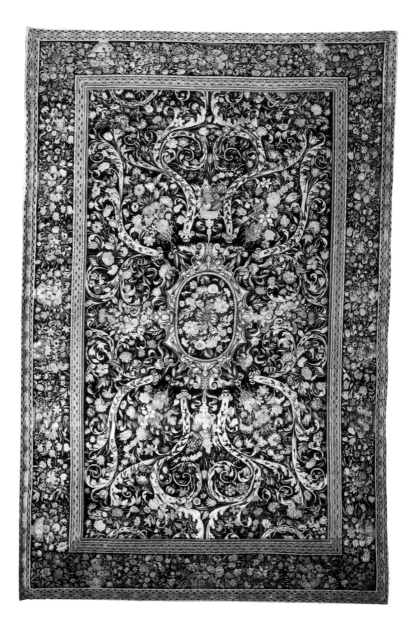

Renaissance drug jar, such as the one shown in figure 11, could be its function, as well as its decoration which is intended to invoke the exotic East, even though the characters of the script are invented and nonsensical: "drugs," "medicines," "pharmacy," "storage," "Middle East," "China," "Islamic knot work," "Kufic script," "Chinese calligraphy," "alphabet." Indexing terms for describing the subject matter of the pair of globes in figure 12 could be "Earth," "heavens," "geography." The subject of a building, such as the J. Paul Getty Museum (fig. 13), could be the building's

Fig. 11. *Cylindrical Jar (Albarello).* Italy, mid-1400s, tin-glazed earthenware, H: 18.1 cm (7⅛ in.); Diam. (lip): 9.5 cm (3¾ in.). J. Paul Getty Museum, Los Angeles

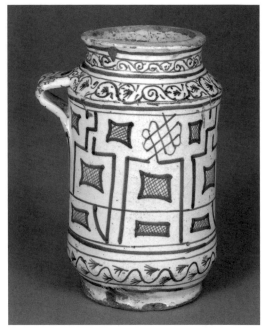

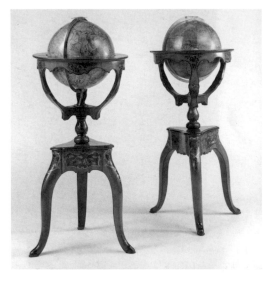

Fig. 12. Designed and assembled by Jean-Antoine Nollet (French, 1700–70); maps engraved by Louis Borde and Nicolas Bailleul the Younger. *Pair of Terrestrial and Celestial Globes.* 1728 and 1730, printed paper; papier-mâché; poplar, spruce, and alder painted with *vernis Martin;* and bronze, each: 110 × 45 × 32 cm (43¼ × 17½ × 12½ in.). J. Paul Getty Museum, Los Angeles

Fig. 13. Richard Meier (American, b. 1934), architect. *Museum Courtyard,* The Getty Center, Los Angeles. Completed 1997. Photo: Alex Vertikoff

function and critical design elements: "art museum," "space," "square," "axes," "reflection," "shadow."

Since information about art is often uncertain or ambiguous, there may be multiple interpretations for the subject of a particular work. Given that interpretations of subjects can change over time and that more than one interpretation may exist at one time, the history of the interpretation of the work should also be noted. For example, the sitter in Jacopo Pontormo's *Portrait of a Halberdier* (fig. 14) is sometimes identified as the Florentine duke Cosimo de' Medici, but he is more often considered to be the young nobleman Francesco Guardi. An "unbiased," objective description would identify the sitter simply as a "halberdier" or "soldier." The

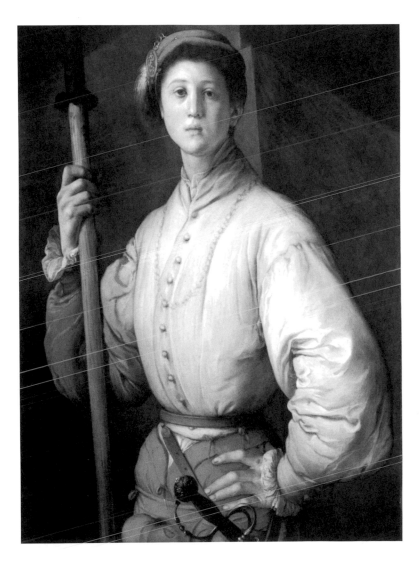

Fig. 14. Jacopo Pontormo (Italian, 1494–1557). *Portrait of a Halberdier (Francesco Guardi?)*. Ca. 1528–30, oil (or oil and tempera) on panel transferred to canvas, 92 × 72 cm (36¼ × 28⅜ in.). J. Paul Getty Museum, Los Angeles

subject matter of this painting should be accessible by any of these subject designations. It is important to have a data structure that allows for this kind of variety and flexibility.

Structure to Allow Subject Access

Fig. 15. Nikodemos (Greek, act. ca. 362 B.C.E.); decoration attributed to the Painter of the Wedding Procession. *Panathenaic Prize Amphora with Lid.* 363–362 B.C.E., terracotta, H (with lid): 89.5 cm (35¼ in.), Diam. (body): 38.3 cm (15¹⁄₁₆ in.). J. Paul Getty Museum, Malibu, California

Among the key decisions that must be made to provide subject access to images is selection of the appropriate format or metadata schema. Indeed, a suitable data structure is essential for creating good end-user access to images. The data structure must include all necessary fields; it must allow repeating fields as appropriate; and it must include links or otherwise accommodate the particular relationships that are inherent between museum objects and works of architecture (or their visual surrogates) and the subjects depicted in them.

The data structure for subject access must be contained within an overall workable data structure for the objects being described or catalogued. To successfully create a versatile, useful information system on art and architecture, several critical issues must be addressed. The institution or cataloguing project must decide what is being catalogued: museum objects, groups of objects, buildings, or visual documents (surrogate images) of those objects or buildings. Other decisions are critical to the format and structure of the system: Which metadata elements or fields are critical? Are there additional optional fields that are desirable but not necessary for retrieval? Which fields should be repeating? Which fields should be populated with controlled vocabulary terms? Should there be linked authorities?

CDWA specifies fields for various attributes of an object record, including a set of fields for subject identification in the category Subject Matter.[4] This set of fields is repeatable, and includes a field for a free-text description of the subject, as well as fields for indexing terms. For the fourth-century B.C.E. Greek amphora shown in figure 15, the free-text description of the subject might be the following: "Side A: Athena Promachos; Side B: Nike crowning the victor, with the judge on the right and the defeated opponent on the left." The important elements of the subject are then indexed with controlled vocabulary

terms to provide reliable retrieval; for example, the indexing terms for this object might be "human male," "human female," "nudes," "Greek mythology," "Athena Promachos," "Nike," "judge," "competition," "game," "games," "athlete," "prize," "festival," "victory." Ideally, all three levels of subject matter (description, identification, and interpretation) should be analyzed and indexed for access, although the terms should be stored in the same table for end-user retrieval.[5] A sample descriptive record for the amphora, formulated according to CDWA guidelines, is shown below (core categories are indicated with asterisks).

Classification*	antiquities	vase painting
	vessels	decorative objects and vases
Object/Work-Type*	Panathenaic amphora	amphorae
Object/Work-Components	amphora	lid
Titles or Names*	Panathenaic Prize Amphora with Lid	
Creation-Creator*	Attributed to the Painter of the Wedding Procession (as painter); signed by Nikodemos (as potter)	
	painter: Painter of the Wedding Procession (Athenian, 4th century B.C.E.)	
	potter: Nikodemos (Athenian, 4th century B.C.E.)	
Creation-Date*	363/362 B.C.E.	
	earliest: −363	latest: −362
Styles/Periods	Black-figure	Attic
	Aegean	Archaistic
Subject Matter*	Side A: Athena Promachos Side B: Nike crowning the victor, with the judge on the right and the defeated opponent on the left	
	Athena Promachos	Minerva
	Nike	prize
	judge	festival
	human male	human female
	nudes	Greek mythology
	victory	competition
Measurements*	Height with lid, 89.5 cm (35 in.); circumference at shoulder, 115 cm (44 ⅞ in.)	
	height: 89.5 cm	depth: 36.6 cm
	width: 36.6 cm	circumference: 115 cm
Materials and Techniques*	terracotta	
	wheel-turned	
	sintering	
Descriptive Note	Amphorae were typically used as storage and transport vessels but were also used as funerary objects and prizes. Vessels such as this one were prizes in the Panathenaea, the annual Greek religious festivals held in Athens and celebrated every fourth year with great splendor, probably in deliberate rivalry to the Olympic Games. There were contests, such as the recitation of rhapsodies (portions of epic poems), and various athletic contests.	
Current Location*-Repository Name	J. Paul Getty Museum	
Current Location*-Repository Location	Los Angeles (California, USA)	
Current Location*-Repository Number(s)	93.AE.55	

Display versus Indexing

For an information system to be effective, information for display and information intended for search and retrieval must be distinguished. A field for display is all that the end-user sees. Information critical for research must, however, also be properly indexed in fields to allow adequate retrieval. The field for description or display can provide a clear, coherent text that identifies or explains the subject. As I have already pointed out, art information can often be ambiguous or even seemingly contradictory. In the display field, uncertainty and ambiguity can be expressed in a way that is intelligible to end-users; words such as "probably" and "possibly" may be used. For example, the subject for one Dosso Dossi painting (see pl. 3) could be described in a display field as follows: "Mythological scene, uncertain subject; probably represents 'love' and 'lust,' personified with central figures that are possibly Pan, Echo, Terra, and an unidentified goddess." The indexing fields would use controlled vocabulary to ensure reliable, consistent access to the same information. All terms representing all possible interpretations should be included for access; for the Dossi painting, the terms could include "Greek mythology," "love," "lust," "cupids," "landscape," "nude," "human female," "flowers," "Pan," "satyr," "nymph," "Echo," "Terra," "elderly female," "armor," "goddess."

Specificity versus Inclusivity

In the Dosso Dossi painting, the indexing terms include all likely interpretations of the subject matter. This is the approach taken by a knowledgeable cataloguer who can be specific in listing the possible subjects. A different approach must be used when the cataloguer does not know the subject due to lack of information—that is, if the information is possibly "knowable," but simply "not known" because the particular cataloguer does not have the time or means to do the research. In such cases, it is advisable to list terms that are broad and accurate rather than to be specific at the risk of being inaccurate. If the cataloguer is not familiar with the scholarly literature addressing the likely purpose of the maiolica jar shown in figure 11, the cataloguer is better off calling it a "vessel" or even a "container" rather than guessing that it may be a "drug jar." For the eighteenth-century French woodcarving shown in figure 16, the cataloguer should not try to surmise the allegorical meaning of the work if he or she does not have research or documentation to support the supposition. In such a case, the cataloguer could resort to performing only the first level (description) of subject analysis, naming the objects clearly seen in the piece: "flowers," "medallion," "bird," "nest." Only if there is credible supporting evidence should indexing terms relating to the allegory—for

Fig. 16. Aubert-Henri-Joseph Parent (French, 1753–1835). *Carved Relief.* 1791, limewood, 58.75 × 39.75 × 5.7 cm (12 × 3⅝ × 2¼ in.). J. Paul Getty Museum, Los Angeles

example, "Constitution of 1791," "French Revolution," "French monarchy," "death," "National Assembly," "failure," "ending"—be added.

Repeating Fields

Repeating fields refers to a data structure in which there are multiple occurrences of a given field, so that multiple terms or data values may be recorded efficiently. CDWA suggests which fields or metadata elements should be repeating. Obviously, the field for Subject Matter should be repeatable. Repeating fields can store indexing terms for all three levels of subject analysis; although these aspects of the subject are analyzed separately, retrieval is more efficient if they are stored together. Multiple interpretations of the subject can also be indexed and recorded in this set of fields.

Authorities

CDWA describes a set of relational tables that includes information about the object along with links to tables that hold information about the

subject in a Subject Identification Authority. There are also links to other authorities as well. In this context, an "authority" is a separate file in which important information indirectly related to the objects being described can be recorded. A "link" may be made between the appropriate field in the object record and the relevant authority record. The relationship of authorities to object records in an information system is presented in the following entity-relationship diagram:

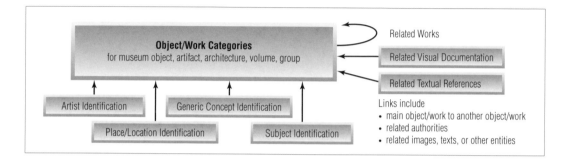

An authority for subjects provides an efficient way to record preferred and variant names, broader concepts, and related information regarding subjects. The information need be entered only once in the authority record rather than in each object record related to that subject. For some subject information, authorities may be efficiently constructed by using previously compiled data.[6] The fields in the CDWA's Subject Identification Authority are Subject Type, Preferred Subject Name, Variant Subject Names, Dates, Earliest Date, Latest Date, Indexing Terms, Related Subjects, Relationship Type, Name of Related Subject, Remarks, and Citations.

The Subject Identification Authority[7] contains fields for the preferred, or most commonly known, name of the subject, as well as variant names by which the subject may also be known; variant names in multiple languages could also be included. Many subjects may be known by multiple names, all of which are useful to include as access points for search and retrieval. Using such a controlled vocabulary or classification system ensures that synonyms are available for end-user access. For example, "Three Kings" and "Three Wise Men" are variant names for the "Magi"; "stag beetle" and "pinching bug" are synonyms for an insect of the family "Lucanidae." Because the cataloguer or indexer has no way of knowing which form or forms end-users will choose in searching, as many variant forms as possible (or reasonable) should be included. The

following sample subject authority record offers several name variants for the preferred name "Herakles": "Hercules," "Heracles," "Ercole," "Hercule," "Hércules." Using an authority or controlled vocabulary ensures that all these synonyms can be used in search and retrieval.

- *Subject Type:* mythological character, Greek and Roman
- *Subject Name:* Herakles
- *Variant Subject Names:* Hercules, Heracles, Ercole, Hercule, Hércules
- *Display Dates:* story developed in Argos, but was taken over at early date by Thebes; literary sources are late, though earlier texts may be surmised.
- *Earliest:* –1000 *Latest:* 9999 *(date ranges for searching)*
- *Indexing terms:* Greek hero, king, strength, fortitude, perseverance, labors, labours, Nemean lion, Argos, Thebes
- *Related Subjects:* Labors of Herakles, Zeus, Alcmene, Hera
- *Remarks:* Probably based on actual historical figure, a king of ancient Argos. The legendary figure was the son of Zeus and Alcmene, granddaughter of Perseus. Often a victim of jealous Hera. Episodes in his story include the Labors of Herakles. In art and literature Herakles is depicted as an enormously strong, muscular man, generally of moderate height. His characteristics include being a huge eater and drinker, very amorous, generally kind, but with occasional outbursts of brutal rage. He is often depicted with characteristic weapons, a bow or a club; he may wear or hold the skin of a lion. In Italy he may be portrayed as a god of merchants and traders, related to his legendary good luck and ability to be rescued from danger.
- *Citations:* Grant, Michael, and John Hazel, *Gods and Mortals in Classical Mythology* (Springfield, Mass.: G & C Merriam, 1973); *Encyclopedia Britannica Online,* "Heracles" (Accessed 06/02/2001)

Other fields are also useful in providing access. In the sample subject authority record for Herakles, a note (corresponding to the Remarks category in CDWA) describes the iconography associated with Herakles and some of the ways in which this figure may appear in works of art. Terms that allow researchers to find all similar subjects must be indexed as well; such indexing provides access to the record (and thus to objects linked to it). In the sample record, examples for Herakles could appear in the "indexing terms" field: "Greek hero," "king," "strength," "fortitude," "perseverance," "Labors," "Labours," "Nemean lion," "Argos," "Thebes." They include places, events, and characters related to the iconography of Herakles, as well as abstract attributes symbolized by the Greek hero (for example, "strength" and "fortitude"). The subject authority can also contain a date field, noting the time frame when the subject may have been developed or when it was first documented. In addition, links to other subject authority records may be useful; the record for Herakles is linked to the records of other protagonists related to the iconography of this mythological figure, namely "Hera" and the "Nemean lion." There can also be a field for listing sources for more information about the subject.

Hierarchical Relationships

Layne stresses in her essay in this volume the power that vocabularies and classification systems with syndetic structures can have for indexing and retrieval. Thus it may be desirable to design an information system that allows for hierarchical relationships for subjects. One way to maintain distinctions among related iconographic themes efficiently is to create a data structure that makes it possible to link records. For example, the episodes of the Labors of Herakles could be linked hierarchically to the general record for Herakles and to even broader concepts such as classical mythology or Greek heroic legends,[8] as shown in the following example from the ICONCLASS system:

9 Classical Mythology and Ancient History
......94 the Greek heroic legends (I)
..........94L (story of) Hercules (Heracles)
.............94L1 early life, prime youth of Hercules
.............94L2 love-affairs of Hercules
.............94L3 most important deeds of Hercules: the Twelve Labours
...............94L31 preliminaries to the Twelve Labours of Hercules
...............94L32 the Twelve Labours: first series
....................94L321 (1) Hercules chokes the Nemean lion with his arms
....................94L322 (2) the Hydra of Lerna is killed by Hercules
....................94L323 (3) the Ceryneian hind of Arcadia is captured by Hercules
....................94L324 (4) the Erymanthian boar is captured by Hercules
....................94L325 (5) Hercules cleanses the stables of Augeas by diverting the rivers . . .
....................94L326 (6) the Stymphalian birds are shot by Hercules, or driven away with . . .
....................94L327 (7) the Cretan bull is captured by Hercules
....................94L328 (8) the four mares of King Diomedes are captured; when Diomedes . . .
....................94L329 (9) Hippolyte, the Amazon, offers her girdle to Hercules
...............94L33 the Twelve Labours of Hercules: second series
.............94L4 aggressive, unfriendly activities and relationships of Hercules
.............94L5 non-aggressive, friendly or neutral activities and relationships of Hercules
.............94L6 suffering, misfortune of Hercules
.............94L7 specific aspects, allegorical aspects of Hercules; Hercules as patron
.............94L8 attributes of Hercules

Vocabularies

Published controlled vocabularies that have gained a degree of acceptance in the visual resources and art-historical communities can be used to record terms for subject matter. If an authority for subject identification is being created for a particular collection or body of material, such controlled vocabularies can be used to "populate" the authority file.

No single authority can provide adequate subject access for most collections. Typically, institutions will have to create an authority for local

use, one compiled, whenever possible, from existing controlled vocabularies. A number of vocabularies are currently available for "populating" local authority files. The ICONCLASS system has proven to be a powerful tool for recording and providing access to iconographic themes, particularly for Western art.[9] This system, developed in the Netherlands and now in use in many countries and institutions, contains textual descriptions of subject matter in art, organized by alphanumeric codes that can be arranged in hierarchies. The *Art & Architecture Thesaurus* (AAT) is a source of terms for describing architectural subjects or objects (for example, "onion dome," "cathedral," "columns"). The Library of Congress's *Thesaurus for Graphic Materials* (TGM), like the AAT, is useful for populating authority files for object type or medium, but it can also provide terms for subject authorities. The *Getty Thesaurus of Geographic Names* (TGN) can provide the names of places depicted in or symbolized by art objects, as can the *Library of Congress Subject Headings* (LCSH). The *Union List of Artist Names* (ULAN) and the *Library of Congress Name Authority File* (LCNAF) can provide pre-ferred and variant names for portraits or self-portraits of artists, as well as for the creators of works of art and architecture.

Other useful vocabularies or term lists could be added to local authorities. Subjects that would be useful for many image collections might include non-Western iconography, Latin names of plants and animals, proper names of people who are not artists (for which the LCNAF would be a good source), events, actions, and abstract concepts (for example, emotions).

Conclusion: The Ultimate Goal Is Retrieval

Obviously, the reason for designing appropriate data structures and devot-ing considerable time and labor to indexing subjects in visual works is to provide good search and retrieval for the images being catalogued or indexed. Therefore, it is crucial to consider current and future retrieval needs of the particular institution and of its various types of users before beginning a cataloguing or indexing project. It is important to keep in mind that the system designed for cataloguing is unlikely to be the same system that will be used for retrieval by the public, so the data created in the editorial or cataloguing system must be exported or "published" to a second system. A certain level of retrieval is required even within a cata-loguing system, however, so that cataloguers and their supervisors can check and organize their work. I think it is safe to say that if data is well organized and catalogued according to recognized standards and using the appropriate vocabularies, "re-purposing" it for various projects and migrat-ing it to new systems in the future (which is inevitable) can be relatively routine tasks. People and institutions that are designing information

systems should be aware that data can be compliant with multiple standards at the same time. Consulting a metadata standards crosswalk can aid in designing appropriate data structures and cataloguing rules so that data can be re-purposed and published in a variety of ways but recorded only once.[10]

In providing retrieval, it is important to remember that subjects are typically requested in combination with a variety of other elements, including the date or date span of the creation of a work, an artist's name, an artist's nationality, the medium or material of a work of art, and the type of object.[11] Furthermore, multiple subjects may be requested at once. Finally, end-users can range from the general public to art historians and other experts. Information systems should allow versatile retrieval for various audiences with different needs and levels of experience.

If Subject Matter and other core metadata elements are well indexed, versatile retrieval is possible. If search is done on the iconographical theme "Adoration of the Magi," the results are those in figure 17. The search could then be narrowed by adding another criterion: for example, narrowing the results to only manuscript illuminations of this

Fig. 17. Sample search results

Top row: results for a search on "Adoration of the Magi," which when narrowed to "manuscript illuminations only" yields the last three images in this row. *Middle and top rows:* results for a search on "Mary and Jesus." *All rows:* results for a search on "mother and child."

Top row, left to right:
Andrea Mantegna (Italian, ca. 1431–1506). *Adoration of the Magi.* Ca. 1495–1505, distemper on linen, 48.5 × 65.6 cm (19⅛ × 25⅞ in.). J. Paul Getty Museum, Los Angeles

Defendente Ferrari (Italian, act. ca. 1500–35). *Adoration of the Magi.* Ca. 1520, oil on panel, 262 × 186 cm (103¼ × 73¼ in.). J. Paul Getty Museum, Los Angeles

Guillaume Courtois (French, 1628–79). *The Adoration of the Magi.* Ca. 1665, red chalk heightened with white, 29.7 × 19.7 cm (11¾ × 7¾ in.). J. Paul Getty Museum, Los Angeles

Jusepe de Ribera (Spanish/Italian, 1591–1652). *Adoration of the Magi.* Spain, ca. 1620, pen and brown ink with a wash over black chalk, heightened with white, 27.6 × 21. 8 cm (10⅞ × 8⁹⁄₁₆ in.). J. Paul Getty Museum, Los Angeles

Workshop of the Boucicaut Master (French, act. ca. 1405–20) and Workshop of the Rohan Master (French, act. ca. 1410–40). *The Adoration of the Magi* from a *Book of Hours,* MS 22, fol. 72. Ca. 1415–20, tempera colors, gold paint, gold leaf, and ink on parchment, leaf: 20.4 × 14.9 cm (8¹⁄₁₆ × 5¹³⁄₁₆ in.). J. Paul Getty Museum, Los Angeles

Georges Trubert (French, act. 1467–99) and Workshop of Jean Bourdichon (French, act. early 1480s–ca. 1520). *The Adoration of the Magi* from a *Book of Hours,* MS 48, fol. 59. Ca. 1480–90, tempera colors, gold leaf, gold and silver paint, and ink on parchment, leaf: 11.5 × 8.6 cm (4½ × 3⅜ in.). J. Paul Getty Museum, Los Angeles

Simon Bening (Flemish, ca. 1483–1561). *The Adoration of the Magi* from the *Prayer Book of Cardinal Albrecht of Brandenburg,* MS Ludwig IX 19, fol. 36v. Ca. 1525–30, tempera colors, gold paint, and gold leaf on parchment, leaf: 16.8 × 11.5 cm (6⅝ × 4½ in.). J. Paul Getty Museum, Los Angeles

Middle row, left to right:
Martin Schongauer (German, ca. 1450–91). *Madonna and Child in a Window.* Ca. 1485–90, oil on panel, 16.5 × 11 cm (6½ × 4⅜ in.). J. Paul Getty Museum, Los Angeles

Workshop of Paolo Uccello (Italian, 1397–1475). *Madonna and Child.* Mid-1400s, tempera on panel, 47 × 34 cm (18½ × 13⅜ in.). J. Paul Getty Museum, Los Angeles

Gherardo Starnina (Italian, act. 1378–ca. 1413). *Madonna and Child with Musical Angels.* Ca. 1410, tempera and gold leaf on panel, 87.6 × 50.2 cm (34½ × 19¾ in.). J. Paul Getty Museum, Los Angeles

Domenico Piola (Italian, 1627–1703). *Madonna and Child Adored by Saint Francis.* 1650–1700, oil on canvas, 24.4 × 19.4 cm (9⅝ × 7⅝ in.). J. Paul Getty Museum, Los Angeles

Cenni di Francesco di Ser Cenni (Italian, act. ca. 1369/70–1415). *Polyptych with Coronation of the Virgin and Saints.* Ca. 1390s, tempera and gold leaf on panel, 355.8 × 233 cm (140 × 91¾ in.). J. Paul Getty Museum, Los Angeles

Circle of Fernando Gallego (Spanish, ca. 1440/45–ca. 1507). *Pietà.* Ca. 1490–1500, oil on panel, 49.8 × 34.3 cm (19½ × 13½ in.). J. Paul Getty Museum, Los Angeles

Attributed to Francesco Mochi (Italian, 1580–1654). *Tabernacle Door with the Crucifixion.* Italy, ca. 1635–40, gilt bronze, 54 × 26 cm (21¼ × 10¼ in.). J. Paul Getty Museum, Los Angeles

Bottom row, left to right:
Joaquin Sorolla y Bastida (Spanish, 1863–1923). *Pepilla the Gypsy and Her Daughter.* 1910, oil on canvas, 181.5 × 110.5 cm (71½ × 43½ in.). J. Paul Getty Museum, Los Angeles

Dorothea Lange (American, 1895–1956). *Migrant Mother, Nipomo, California.* March 1936, gelatin silver print, 34.1 × 26.8 cm (13⁷⁄₁₆ × 10⁹⁄₁₆ in.). J. Paul Getty Museum, Los Angeles

Circle of Jacopo Sansovino (Italian, 1486–1570). *Venus and Cupid with a Dolphin.* France, ca. 1550, bronze, 89 × 35.5 × 30.5 cm (35 × 14 × 12 in.). J. Paul Getty Museum, Los Angeles

event—via the Object/Work-Type metadata element—would retrieve the last three images in the top row. If the objects have also been indexed by individual characters and elements of the scene and by broad themes, users could ask numerous questions. If a user asked to see all images of "Mary and Jesus," the images in the first and second rows would be among the results, including scenes of "Madonna and Child," the "Coronation of the Virgin," the "Pietà," and the "Crucifixion." If a user asked to see images of "mother and child," the last row would be added to the results.

As Colum Hourihane points out in the next essay, subject matter is one of the two main criteria end-users employ in searching for images of works of art. Careful consideration and application of standards and controlled vocabularies are critical to success in providing good end-user access to artworks via their subject matter.

Notes

1. The metadata element set I chose to use here is *Categories for the Description of Works of Art* (CDWA) because of its exhaustivity and focus on art-historical research. But any appropriate metadata schema, such as the *VRA Core Categories* or even the *Dublin Core Categories,* if consistently applied and properly populated with controlled vocabulary values, could be used.

2. Erwin Panofsky, *Studies in Iconology: Humanistic Themes in the Art of the Renaissance* (New York: Oxford Univ. Press, 1939; New York: Harper & Row, 1962). Panofsky's discussion of iconology and iconography appears in the introduction to this work. It is concerned with a philosophical distinction between the references in art to literary sources and traditions of imagery, and the underlying tendency of the human mind to interpret an image and its position in the "cultural cosmos." Panofsky discusses primary or natural subject matter, which can be factual or expressional; iconographic analysis, which deals with images and allegories and requires a familiarity with known themes or concepts; and iconographical interpretation or "iconology," which deals with intrinsic meaning or symbolic values.

3. For more on artist John M. Miller's interpretation of this work, see <http://www.getty.edu/art/exhibitions/past/departures/miller/index.htm>.

4. CDWA lays out 225 subcategories of information in thirty-one broad categories. Nine categories considered "core" information are recommended to allow retrieval for scholarly research: Classification; Object/Work-Type; Titles or Names; Measurements; Materials and Techniques; Creation Date; Creator; Current Location; and Subject Matter.

5. Unless the decision is made to differentiate among the different levels of subject to improve precision in retrieval. I believe, however, that in most cases this would

add a level of complexity that would unnecessarily burden those who are building
the system and provide little, if any, added benefit to the end-user.

6. For example, a museum or image archive could use its existing list of subject
headings as a starting point, or it could populate a local authority file with artists'
names from the ULAN or the *Social History and Industrial Classification* (SHIC)
<http://www.holm.demon.co.uk/shic>, with plant names from the *International
Code of Botanical Nomenclature* (ICBN) <http://www.biosis.org/zrdocs/codes/
icbn.htm>, and so on.

7. See <http://www.getty.edu/research/institute/standards/cdwa/4_categories/
2_authorities>.

8. In his essay in this volume, Colum Hourihane discusses how ICONCLASS
links broader, more general subjects and themes to more specific iconographic
subjects.

9. Henri van de Waal, ICONCLASS: *An Iconographic Classification System*
(Amsterdam: North-Holland, 1973–83). The ICONCLASS system, which has
been updated many times since the last print volume was published in 1983, is
available on the World Wide Web at <http://www.iconclass.nl>.

10. To see a metadata standards crosswalk that cross-references standards related to
art and cultural heritage information, go to <http://www.getty.edu/research/
institute/standards/intrometadata> and click on "Crosswalks."

11. For issues related to these other metadata elements, see Christine Sundt's essay
in this volume.

It Begins with the Cataloguer: Subject Access to Images and the Cataloguer's Perspective

Colum Hourihane
Director, Index of Christian Art
Princeton University

Analyzing the subject matter or iconographic content of images has a long and distinguished history stretching back to the pioneering efforts undertaken by scholars such as Cesare Ripa in the seventeenth century.[1] From such beginnings, numerous more or less systematic attempts have been made to develop structures and approaches for classifying image content in a number of disciplines, one of the most recent being that of art history.

Most cataloguing systems include one or more metadata elements or database fields for content or subject classification, and the relative position of this category or element within the overall structure of the system is usually indicative of its importance in the entire cataloguing process. A number of recent studies have shown the significance of subject access to images and the importance of this metadata element in the electronic environment.[2] After the element of creator/artist/maker, that of content or subject matter appears to be the most widely used in online queries for art-historical material. In other words, many end-users tend to search for art images using the search criteria *who* created the work and *what* is the work *of* or *about*.

The process whereby the subject matter of an image is described or catalogued in an objective textual description is complex. I would argue that, of all the different stages involved in creating access to an image, that of cataloguing is the most significant. The cataloguer or iconographer acts as a conduit between the work of art (or a visual surrogate of it) and the end-user or researcher. Online access to the work of art or its content is only as good as the work done "behind the scenes" by the cataloguer. These two people—the end-user and cataloguer—as well as the two stages in which the image is first viewed by the cataloguer and later retrieved by the end-user, are totally independent of each other and usually are separated in time and space; but they are also indefinably linked by very real levels of verbal and nonverbal communication. The cataloguer is generally the only human or subjective element involved in the classification process, and the ultimate success or failure of end-user retrieval rests with

that individual. Until the time when content-based image recognition is more developed,[3] the cataloguer will remain central to the classification process, and it is only by understanding the approaches and possibilities involved in the task of cataloguing that we can improve this crucial stage of creating access to images. Despite the importance of this individual, I know of no studies on the role of the cataloguer in the classification process or on the methodology used in image classification. This essay is an attempt to describe and understand that role and that methodology.

The two elements upon which I believe good cataloguing depends are *structure* and *methodology,* and these are the focus of my analysis. *Structure in cataloguing* centers on the cataloguer's understanding of the general practices and rules of analysis and classification, as well as on his or her knowledge, expertise, and experience. *Methodology in cataloguing* is in many ways dependent on good structure in cataloguing and on the cataloguer's understanding of how to apply metadata standards, controlled vocabularies, and classification systems. Underlying both should be the goal of meeting users' needs.

Structure in Cataloguing

Structure for the image cataloguer has to do with the way in which content is viewed, analyzed, interpreted, and presented. A cataloguer approaches subject matter in a number of sometimes almost imperceptible stages, and these must be understood for successful cataloguing and ultimately successful end user retrieval. The approach of a general observer, who may simply look at an image for pleasure or interest, differs significantly from that of a professional cataloguer, whose main task is to systematically analyze and classify the elements in an image for eventual use by end-users; cataloguers make end-user access possible. The cataloguer's perspective must be that of a "professional" viewer or analyst in which subjective elements are abandoned and consistency in structure and approach predominates. While there have been several studies of the psychology of perception and recognition,[4] to my knowledge none has addressed the psychological processes or methodology of the cataloguer.

Structure in Viewing, Analyzing, and Interpreting
Critical to understanding the actual cataloguing process is the psychology of approach—the way in which we consciously or subconsciously look at a work of art and the impact this may have on cataloguing content. The first stage in the cataloguing process begins with initial exposure to the work, one of the least understood stages in the entire process. Although this stage can have a major impact on the end result, it has never been fully researched or formally incorporated into the cataloguing process, which is

usually defined as beginning with formal analysis and interpretation. Nevertheless, the initial "viewing" process—which precedes the more clearly defined and better known stage of subject analysis—is critical from the cataloguer's perspective.

Throughout the following discussion, it is important to keep in mind that the cataloguer usually works in a controlled environment in which images must be analyzed and described with little concession to casual viewing; speed is usually a significant factor. The viewing process is one in which subjective emotions can affect what is described; it is necessary to understand what we mentally do when we see a work of art and to understand how changes in this process differ between the general viewer and the cataloguer. The viewing process for the general viewer is normally one in which little structure is imposed; the cataloguer, however, must impose a degree of formality upon the way he or she views images. General viewers are free to spend as much or as little time as they want looking, and they are under no obligation to move beyond what they want to see.

Unlike casual viewers, cataloguers must train themselves to look at every work of art to be described in a consistent, ordered, and paced manner. The general viewer can dislike and mentally reject an entire work or certain elements of it or can focus only on those parts to which he or she can relate, all without affecting anybody else's perception. But a professional cataloguer's main task is to systematically record every "important" element within the work, "translating" these elements from a visual to a textual "language," to echo Patricia Harpring's observation in the preceding essay in this volume.

In viewing an image, the professional cataloguer must impose structure not only on the way in which subject matter is recorded but also on the way the work is viewed. The casual, random approach to viewing must be abandoned. The cataloguer must be aware of what is in the entire image, not just portions of it. Classification must move from a general visual analysis of the work as a whole to a detailed evaluation of its constituent parts.

In looking at Nicolas Poussin's *The Holy Family* (pl. 5), for example, a viewer's eye can immediately focus on any one of the many rather complicated visual elements in the composition. It may be the family group on the left to which the eye is first attracted, or the group of infant boys on the right, or the scene in the background of a man in a small boat ferrying a woman. The cataloguer must, however, approach the entire work in a structured and comprehensive manner, first focusing on the main subject matter and then proceeding to describe its constituent parts. Using the ICONCLASS system[5] to describe this work, a catalogue entry might read as follows:

73B8211	Holy Family with John the Baptist, Elizabeth present
33A14	embracing (John the Baptist and Jesus)
73B2	adoration of the Christ-child
92D1916	cupids, 'amores,' 'amoretti,' 'putti'
31A5463	towel
41A2415	jug and basin
41A7751	basket
41A645	ruins
41A64	garden ornaments, ewer
41A773	container of ceramics, jar, jug, vase, pot
25I2	village
25G3	tree
43C212	racing on an animal mount
46C1111	crossing a river

This entry deals primarily with the main subject of the Holy Family and the significant interaction (embracing) between the two main figures in this group, the Christ child and the infant John the Baptist. The next important visual element is the group of putti and their interaction (adoration) with the Holy Family. From here, classification proceeds in a clockwise direction to the other elements within the composition.

Such an approach attempts to include all the main visual elements that might be of interest to a researcher. Doubtless, classification could proceed further to include details such as the types of flowers and plants, but a decision has to be made as to what is of potential value to users and what is merely staffage—that is, visual "accessories" with no particular thematic significance; of course, time and money also play an important role in limiting the extent of classification in any given project.

Associated with the ICONCLASS alphanumeric notations (which can, and indeed probably should, be "hidden" from the end-user) and their textual correlates is a rich set of keywords, which is really what forms the searchable element or interface to images indexed using the ICONCLASS system. The keywords for the ICONCLASS notations listed above include the following:

Bible, New Testament, Christ, infancy, Christ-child, Mary (Virgin), Joseph (Saint), Holy Family, John the Baptist (Saint), Elizabeth (Saint), human being, biology, mind, spirit, expression, face, mouth, lips, pressing, kissing, society, civilization, culture, housing, garden, ornaments, cloth, toilet articles, bathing, washing, hygiene, care, body, human figure, corpo humano, man, woman, jug, wash basin, bathroom, ancient history, classical antiquity, history, mythology, gods, heaven, serving, Cupid, Love, offspring, companion, train (retinue), cupid, village,

> landscape, world, earth, nature, recreation, movement, speed, games, exercise, sport, animal, riding, race (contest), transporting, land, road, ford, crossing a river, traffic

These keywords include high-level concepts such as "society," "civilization," "culture," and "classical antiquity" that an end-user would rarely use as search terms. Nevertheless, such keywords can offer a way to group items by broad concepts and are automatically carried along with more specific keywords such as "kissing," "village," "crossing a river," and so on.

Cataloguing the same image using the Garnier system[6] presents us with a different approach, which is interesting to compare to the ICONCLASS method; in Garnier, controlled terms are used rather than alphanumerical notations linked to textual correlates. Although the Garnier system provides less detail than ICONCLASS with regard to the main iconographic theme (the Holy Family), like ICONCLASS it moves from broad themes, such as "biblical scene," to specific details, such as "boat" and "horse," as shown below:

> Scène biblique
> Sainte Famille[7]
> Sainte Jean Baptiste (le Précurseur)
> putti
> extérieur: décor d'architecture
> rivière
> barque
> arrivée
> cheval
> cadre urbain

How do we structure an approach to *viewing* an image as distinct from structurally *classifying* its content? The cataloguer first has to control the tendency to describe by intuition and instead structure his or her personal perceptions. Structure enables the cataloguer to methodically, consistently, and comprehensively view and record every significant element in the work. Visual content can be "read" as if it were text. When reading a sentence, for example, the reader may approach the words from left to right, right to left, or top to bottom, depending on the language. But in every case the reader reads in a consistent and methodical manner, never beginning from a randomly selected word in, for example, the middle of a sentence. In the realm of images, it is possible to read from "the beginning" as well. It is possible, however, to begin "reading" a visual work in the middle, as in Islamic manuscript illuminations showing Muhammad resolving the dispute at Ka'ba, where the central focus is the figure of Muhammad and the secondary material revolves around him; or in cruci-

fixion scenes, where the main subject in both visual and thematic terms is the figure of Christ on the cross, which more often than not occupies a central position in the work. For works in which the main element is not at the center of the composition, the approach of "reading" from left to right or right to left or top to bottom can be used. This approach can vary from work to work and clearly depends on the nature of the particular image; the point is that there is an ordered manner in viewing and describing content.

One of the most structured approaches to reading an image is the Index of Christian Art at Princeton University.[8] For example, in describing two panels from the bronze doors created by Andrea Pisano in 1330 for the Baptistery in Florence (figs. 18, 19), the Index of Christian Art employs a combination of subject terms and free-text descriptions, as shown in the following example, which depicts a typical Work record for the two panels, one showing the body of John the Baptist being borne to burial, the other the actual burial. Controlled keywords and keyword phrases are used in the Subject field, and free-text descriptions appear in the Description field.

Original Location	Florence: Baptistery
Name of Work	Florence Baptistery, Andrea Pisano Doors
Medium	metal
Object Type	door
Material	bronze-gilt
Subject	right valve, zone 5
Subject	John Baptist: borne to burial John Baptist: burial
Description	John Baptist: borne to burial — body of John carried by six disciples; John Baptist: burial — body of John placed in sarcophagus, one holding candle; canopy above
Artist	Andrea Pisano
Style	Gothic
School	Italian, Tuscan, Florence
Date	1330
Bibliography	Kreytenberg, G., *Andrea Pisano* (1984), figs. 20–21 Moskowitz, A., *Sculpture of Andrea and Nino Pisano* (1986), figs. 24–25

The Index of Christian Art subject authority record for the iconographic theme of the burial of John the Baptist includes the ICON-CLASS alphanumeric notation, textual correlate, keywords, and bibliographic reference, in addition to the local controlled keywords ("John Baptist: burial") and other local data elements, such as the type of subject:

Subject	John Baptist: burial
Subject	Type scene
Period of Saint	New Testament
Textual Reference	New Testament, Matthew 14:12
ICONCLASS Notation	73C134
ICONCLASS Textual Correlate	Lamentation and death of John the Baptist
ICONCLASS Keywords	Bible New Testament John 01 Matthew 14 Mark 06 John the Baptist (St.) martyr death lamenting burial
Bibliography	Réau, *Iconographie de l'art chretien*, II (1) 459

Every word in a textual sentence has to be read for sense to be made of the sentence; the same holds true for all the elements in a work of art. The initial viewing of a work of art is a process that corresponds to a great extent to the first stage in Erwin Panofsky's three levels of image description, which are discussed by Sara Shatford Layne and Patricia Harpring in their essays in this volume. (Initial viewing differs from Panofsky's "description," however, in that the viewing process need not necessarily preclude an element of analysis or interpretation.) Structure in viewing an image is a learned process that involves training the brain both to slow its natural inclination to focus on selected subjective elements and to see the entirety of the work with all of its constituent parts.

Reading an image in an orderly, structured manner can help ensure comprehensive coverage of every element from the least significant to the most important. For example, in Jan Steen's *The Drawing Lesson* (pl. 6), the work should be read first in terms of the most important element or activity in the image—the actual lesson and those involved in it. The remaining elements in the image can then be recorded in an ordered manner, from left to right, if so desired. Using a series of controlled keywords, the subject matter of this work might read as follows:

> *Primary subjects:* drawing lesson; artist training pupils; studio; implements of artist; Vanitas; personification of time; personification of temporary nature of art
> *Secondary subjects:* model cast; woodcut; male nude; sculpture; ox; easel; painting; musical instrument; violin; canvas; drawing; carpet; furniture; chest; still life; wreath; skull; wine; clothing; book; pipe; window; container; frame; work associated with Jan

Fig. 18. Andrea Pisano (Italian, ca. 1290–ca. 1348). *The Body of John the Baptist Being Borne to Burial.* Panel from proper left leaf of the south doors, Battistero di San Giovanni, Florence. 1330, gilded bronze, inside molding: 54 × 43 cm (21¼ × 16⅞ in.)

Fig. 19. Andrea Pisano (Italian, ca. 1290–ca. 1348). *Burial of John the Baptist.* Panel from proper left leaf of the south doors, Battistero di San Giovanni, Florence. 1330, gilded bronze, inside molding: 54 × 43 cm (21¼ × 16⅞ in.)

Lievens; artist, teaching; drawing; draughtsman; draftsman; workshop; studio; brush; painters' tools; pencil; charcoal

Viewing is a process that rapidly develops into the critical stage of formal analysis and interpretation, but it can occur only after all the elements in a work have been viewed and identified. Analysis and interpretation are dependent on a number of factors, the most important of which are the knowledge, skills, and expertise of the cataloguer. A great deal also depends on the nature of the material being catalogued. If the collection is more or less focused on a particular style, period, or geographic area, and the end-user is likely to have a similarly specialized knowledge, then the cataloguer also has to have more than a passing acquaintance with the subject to proceed with adequate classification. If the collection is art-historical in the broadest sense, however, with no particular focus on period, style, or geographic area, then a cataloguer with broad knowledge will offer the best results. By and large, the best art image cataloguers are generalists with a good working knowledge of most subjects; cataloguers with expertise in a particular style or period may produce records that are too narrowly focused and that even omit access points that many end-users would likely use. A general rule might be to use specialist cataloguers for specialized collections (or for specific projects with a very definite focus

(for example, images of Hindu gods, seventeenth-century French decorative arts) and generalists for more encyclopedic collections.

Good subject classification demands that every important element in a work be described first; this corresponds to Panofsky's "pre-iconographic" level of pure description. Only after the first phase has been completed should the cataloguer add a level of interpretation to the objective description. It is good practice for the cataloguer to include broad concepts underlying the more obvious descriptors, thereby making available searchable terms that may not be included in the specific terms. For example, in cataloguing one of William Wegman's famous images of Weimaraners, a cataloguer might want to include keywords such as "sporting dog," "dog," "mammal," and "animal,"[9] unless such terms are already included in the syndetic structure of the thesaurus being used to assist end-users in their searches.

The cataloguer does not rely solely on what is represented in the work of art; he or she also draws on sources external to the work. External elements can come from the title of the work, the wall label in a museum or gallery, a literary work, reference books, and so on, but the most important external source is undoubtedly the knowledge from personal experience and formal education that the cataloguer brings to an interpretation or analysis of the work. In terms of access, the most immediate source of knowledge that can add to our understanding of the work is usually the title. Even though the title may have been assigned to the work long after the artist parted with it and may bear no relation to what the artist intended, it is usually an invaluable source of information, particularly in the area of modern art. When faced with a nonrepresentational work, such as one of the abstract paintings in Richard Diebenkorn's famous *Ocean Park* series, the title adds a level of meaning that not only can be recorded in subject classification but also is more useful than simply classifying the work as "abstract" or "nonrepresentational." Even when scholars know that the assigned title of a particular work does not relate to what the work actually represents, it is important for the cataloguer to record the obsolete information. The identification of sitters can change over time,[10] yet, even when modern scholarship provides irrefutable proof of another identification, the superseded name must be recorded as well. One such work is Rembrandt's painting at the Prado in Madrid. Over time, its subject has been identified as Lucretia, Sophonosba, Cleopatra, and, more recently, Artemisia. The sitter has also been identified as Saskia van Uylenborch, the artist's wife. Data such as these should, at all times, be included in the metadata element or database field dedicated to subject matter in an information system.

Context can also add to our understanding of subject matter. This is particularly true when works are part of a narrative sequence—that is, when there is a broader context or location of which an individual work

is just a part. For example, sculptural programs on the exteriors of medieval cathedrals can provide immediate clues as to the likely subject matter of an individual sequence. Prophets are frequently found in the same location, personifications are similarly grouped in relatively few areas, and general subjects are nearly always ordered in an identifiable sequence. Similarly, manuscripts such as Bibles, missals, and books of hours follow sequential patterns where context can enlighten the cataloguer as to the likely subject matter. Miniatures in such works usually relate to the text and are likely to be ordered in a set narrative.

Three additional indirect sources of information for the cataloguer involve the artist, date, and style of a particular work of art. As Christine Sundt points out in the following essay, the cataloguer can sometimes use these elements to identify or qualify content and to place the specific work within the broader framework of the artist's output.

It goes without saying that a good library of reference works appropriate to the material in the image collection is essential for every cataloguer. Encyclopedias, geographic and cultural guidebooks, and dictionaries are essential cataloguing tools. Along with the standard print publications, cataloguers should investigate the many electronic resources that are rapidly gaining acceptance and being used with greater frequency by increasing numbers of cataloguers.

Structure in Interpretation

Under ideal conditions, the cataloguer first views an image and interprets its compositional elements in light of his or her experience and knowledge. An art image cataloguer with a certain cultural and visual background will immediately recognize, for example, a reproduction of Leonardo da Vinci's *Mona Lisa,* a photograph of the Taj Mahal, or an image of a Native American totem pole. In such cases, recognition and interpretation are immediate (sometimes even intuitive) and nearly always based on the cataloguer's knowledge.

When recognition occurs so quickly, the cataloguer may be unaware of the actual process of interpretation; it is not until the process becomes more paced that its stages can be understood. This happens, for example, when a cataloguer does not recognize the landscape or the individual represented in a particular image. Then the process of interpretation begins consciously. There is usually little difficulty at the initial stage of analysis, which loosely corresponds to Panofsky's pre-iconographic stage. At this stage, the cataloguer works from the broadest subjects or concepts to the most detailed when these are known. When the subject matter is not known, the iconographer builds toward an interpretation using the most detailed clues in the image and approaching a broader interpretation.

One of the great problems in image classification is the inability to distinguish between subject matter and information that tangentially relates to content, such as the style or the date of a work of art. The inclusion of such incidental information in formal classification structures exacerbates the confusion. In Garnier's system, for example, style and date are included in the classification system. Style and date are metadata categories or elements that relate to object and not to subject classification. The concept of style should be included in subject classification when a work of art with a recognizable style is represented within the image being classified. For instance, the subject classification for a seventeenth-century painting depicting galleries or private collections in which connoisseurs peruse a large group of paintings or images of classical architecture by artists such as Sir Lawrence Alma-Tadema should mention the style of the paintings represented within the scene. Otherwise, the concept of style or school or date should be recorded in metadata categories (and the fields in a database or information system that correspond to those metadata categories) other than the category intended for recording subject matter.

It is easy to classify subject matter in terms of what is identifiable in an image; the two major difficulties lie in deciding what should not be included and in attempting to classify concepts that are not explicitly represented. If it is difficult to distinguish what should not be included, it may be easier to decide what should. An unwritten rule in subject classification is to include even the minutest detail as long as this detail is depicted with sufficient clarity to potentially be of value to end-users. The users' needs should always determine whether an element should be recorded. Experience has shown that users rarely look for a single element at a time; they are usually seeking what they request in their query in combination with some unstated element or elements.

The process of subject classification should be reasonable and sensible, and there are a number of obvious and implicit rules as to what should be included and what can be excluded. For example, most good image cataloguers would not include the concept of "sky" when describing a landscape unless the sky is particularly dramatic or unusual (as in Constable's studies of clouds or Turner's images of skies). Similarly, the concept of "interior" or "exterior" need not be explicitly stated except when it is of particular significance. Such concepts are implicit in the higher-level descriptors "landscape" or "sitting room" but are not formally structured or inherent in most classification systems. ICONCLASS is an example of a classification system that carries the higher-level descriptors into the lower levels; thus a descriptor such as "King David" would carry with it the higher-level terms such as "religion," "Bible," and "Old Testament."

A major difficulty arises when the cataloguer is faced with the need to encode abstract concepts, ideas, or emotions—what Panofsky

called the *iconology* of a work of art. A prominent characteristic of Victorian art, for example, and one that is frequently of greater importance than the recognizable elements in individual works, is the moral message or didactic purpose behind the artist's image. Objective elements in a work of art can be easily classified, but it is frequently impossible to specify exactly what was intended when it comes to the more abstract messages that the artist wished to convey. The dividing line in visual representations of emotions or abstract concepts such as despair, sadness, destitution, poverty, and isolation is extremely fine, so it is important to include as broad a range as is practical.

Cataloguers should always try to put themselves in the place of their end-users with regard to the value of seemingly insignificant elements in an image. Qualifiers such as position, detail, and relationship with other elements can be used to gauge the importance of such elements in a visual work. The argument to exclude insignificant elements is stronger when they are clearly background details or staffage. As a general rule, however, if a detail can be specified, then it should be. Moreover, details should be either included or excluded as standard practice rather than according to the likes or dislikes of the individual cataloguer.

This element of consistency is important, especially in classification systems that allow the cataloguer to enter specific details. In most classification systems, the cataloguer can enter the details of generic objects that are specific to the work being catalogued. The names of people, bridges, or cities may be listed, or the scene from a Shakespearean play, to give just a few examples. It is important in such instances to structure the details consistently and to use interchangeable international standards wherever possible.

Methodology in Classification

Closely related to the way in which the cataloguer approaches content is how that content is recorded and the standards that are used. The importance of standards cannot be overemphasized. For the cataloguer, standards exist both in the systems that can be used to classify subject matter and in how those data are structured within these systems. Whatever cataloguing structure, vocabulary and classification tools, and information system are selected for a descriptive cataloguing project, it is imperative that sharing information in the broader community be considered and enforced from the start.

Whereas most of the standards used to classify art-historical content have been specifically developed for this purpose (unlike the early days, when bibliographic standards were applied to visual material), many have been adopted from the broader information universe and include, for example, standards such as the *Anglo-American Cataloguing Rules*.[11]

Once cataloguers recognized that textual and visual materials are vastly different, systems of subject classification began to proliferate, and they continue to develop at an alarming rate.[12] And once cataloguers began harnessing information technology for art-historical classification, interest in classifying content was renewed, which has led to the wheel being constantly reinvented. Systems have either been collection-generated or structured independently of any particular collection of objects or visual materials. The former, which outnumber the latter, are more specific in focus, with narrower applications. The latter, which include ICON-CLASS, the Garnier system, and the *Art & Architecture Thesaurus* (AAT), attempt to be much more inclusive. Increasingly, museums and image archives have been building classification systems and indexes specific to their own collections, populating them with data values taken from systems such as ICONCLASS or the AAT. Some vendors of collection management systems now offer both a thesaurus construction module and structured vocabularies (such as the AAT) "built in" to facilitate populating local authorities or classifications with terms from recognized, standard vocabularies.

Classification systems can and in fact should differ in the way in which they are applied by cataloguers and indexers, and the way in which they are made available to end-users. When used to tag or index items in an information system, classification systems and vocabularies must be rigorously applied and need not be user-friendly, except to the professional cataloguers using them. The public face of such structures must be user-friendly and easy to understand, however. ICONCLASS is an example of such a dual-natured system, where the cataloguer applies a series of alphanumeric notations or codes that would be off-putting as well as meaningless to an end-user. End-user access to these notations is made possible through a series of natural-language keywords, rather than through the forbidding alphanumeric codes.

Classification systems can use free-text descriptions or controlled vocabularies, not that the former preclude control. Each has its own particular value, and the ideal is one where both approaches are used and complement each other.[13] Free-text descriptions enable the cataloguer to give an unrivaled mental image of the subject matter of the work of art and, in particular, to describe the relationship of elements to one another within the work. The location of a particular subject in the image ("left foreground," "right background"), the relationship of elements ("to the right of," "above this," "immediately to the left of"), or colors ("yellow hat," "red wings") can be conveyed with little difficulty. Such free-text descriptions need not be extensive and should convey only objective accounts of content. Their most obvious fault is that they introduce an element of inconsistency, in that the cataloguer is free to

use natural language rather than controlled keywords or structured strings of terms.

Controlled descriptors, which are certainly the most popular means of describing visual content,[14] consist of either alphabetically arranged headings or descriptors, such as the *Library of Congress Subject Headings* (LCSH), which include some shallow hierarchical relationships but as a whole are not structured hierarchically like a thesaurus, or of terms that carry with them hierarchical relationships. These relationships range from the broad to the specific (such as ICONCLASS, AAT, and Index of Christian Art subject terms).

Individual headings from a straightforward alphabetical list might seem to be easier to apply and easier to retrieve; in reality, greater coverage and more powerful searching capabilities are possible with a hierarchically structured system, where more context is given for individual themes or concepts, and it is possible to relate elements within a broader framework.

Another aspect of end-user searching, which the other authors of this publication also mention, is the fact that elements such as titles or captions—alone or in combination with the subject matter element and other elements such as date, style, or period—are frequently employed by end-users seeking subject access to visual materials. End-user systems and user interfaces need to take this into account.

Primary-Secondary-Tertiary

Most classification systems attempt to prioritize subject matter, usually on the three different levels Panofsky called *description, identification,* and *interpretation.* This approach to viewing and recording content more often than not also reflects the mental approach of the viewer. Even when there are no corresponding formal divisions in a particular database structure, it is still advisable to mentally approach content in terms of such a tripartite division and to classify content in terms of highest to lowest priority. As a general rule, the cataloguer should regard the primary level as the overall theme or subject; this is usually a broad type of descriptor such as "portrait," "seascape," or "still life." From my own experience, I would recommend that no more than three or four such high-level terms be used; when more are used, it is nearly impossible for the end-user to understand what the main subject is without actually seeing the work.

The age-old belief that the main subject of a work of art is the one that visually predominates does not always hold true; hence, it is up to the cataloguer to determine what is most significant. More than anything else, it is the cataloguer who determines what is important and what should be classified and how. Image quality, when the cataloguer is working with a reproduction of the work of art, can often significantly affect

cataloguing. Poor-quality images, where details cannot be seen, can impede the classification process; black-and-white images can prevent color significance from being included.[15] Under ideal circumstances, cataloguing should proceed only where image quality is good enough for the cataloguer to see all the details of the work being catalogued. In practical terms, however, cataloguers usually have to work with the images available to them; under such circumstances it is advisable to include as much as possible, even when there is some ambiguity.

Once the primary level descriptors have been applied, most classification structures offer the opportunity to classify a combination of generic types, as well as details specific to that work of art. An image may be a view of a bridge, but if the particular bridge can be identified, that fact should be recorded in an orderly and structured format. ICON-CLASS provides a flexible yet consistent structure within which "named" elements can be identified. In classifying a bridge in an image, for example, the final notation (25I1451) is built in a series of stages, each of which has its own associated keywords.

2	Nature
25	earth, world as celestial body
25I	city-view, and landscape with man-made constructions
25I1	city-view in general, *'veduta'*
25I14	public road
25I145	canals, waters (in city)
25I1451	bridge in a city across a river
25I (USA, NY, NEW YORK, BROOKLYN) 1451	

Underlying this notation are the searchable keywords "nature," "earth," "world," "landscape," "veduta," "city-view," "ideal city," "public road," "road," "canal," "river," "bridge."

In handling the individual elements of an image, structure is imperative not only in terms of data entry but also in terms of retrieval. If terms are controlled, it is important that other cataloguers, in a shared environment, be able to access them to avoid duplication. Standards should be used in formulating strings of keywords or textual references. Even when it comes to naming a generic type of object depicted in an image, such as a piece of fruit, it is important to have well-defined data entry rules: Is the singular or the plural ("apple" versus "apples" versus "apple(s)") to be used? Issues such as case sensitivity in searches ("Apples" versus "apples" versus "APPLES") can be resolved using information technology, but the decisions about how to handle such policies must be decided in advance by the individuals who are building those systems and writing the rules for data entry in them. As we have seen throughout this volume, the use of syndetically structured vocabularies can overcome dif-

ferences in the terms used to describe or search for the same item (for example, "aubergine" versus "eggplant").

Organizing data into significant groupings is also useful, especially when large bodies of similar material are being catalogued. Even high-level descriptors can prove invaluable both for accurate search and retrieval and to enable users to browse through similar items. For example, American cityscapes could be prefaced with the International Organization for Standardization (ISO) three-letter country code USA, French cityscapes with FRA, and so on.[16] If one is using a true thesaurus such as the *Getty Thesaurus of Geographic Names,* it is easy to construct hierarchical strings that go from the nation down through states, counties, and other political subdivisions to the level of detail desired, until the specific place is named:

> FRA, Haute-Normandie, Seine-Maritime
> SYR, Damascus
> GBR, Oxfordshire, Blenheim Palace
> USA, CA, San Francisco

Representations of scenes from different works of literature, operas, and so on can be similarly structured, as can geographic names such as "Persia" or "Flanders," which no longer exist as political or administrative entities. All these kinds of groupings enable speedier and more efficient retrieval, as well as consistency in cataloguing.

In deciding what structure to use, it is necessary to look at factors such as the nature of the material being catalogued, the level of detail to which cataloguing will be done, the information system that will be used, and, first and foremost, who the users are who will query the information system and what their needs are.

If the material is diverse in nature and covers different periods, media, and styles, then the cataloguing process will clearly take longer than in a narrowly focused image archive in which similar subject matter predominates. In an image collection with diverse materials, workflow charts in which different individuals, ideally each with expertise in a particular area, are assigned particular areas of responsibility can facilitate the cataloguing process.

The level of detail to which cataloguing takes place and the experience and skill of the cataloguers are determining factors in the success or failure of a cataloguing project. Traditionally, image archives have opted for a fairly minimal subject record in which only four or five terms were applied to an image, in the belief that these records could be upgraded in the future. Unfortunately, such improvements rarely take place. The alternative approach has been to catalogue images in detail from the outset, which is certainly more time-consuming but enables greatly enhanced end-user access to the material. If staffing and resources permit, I believe

that it is advisable to choose the latter approach and to provide as extensive coverage as possible.

Conclusion

A survey of members of the Art Libraries Society of the United Kingdom (ARLIS/UK) showed that content classification in art image repositories is performed chiefly by "librarians," "archivists," or "cataloguers."[17] These people are trained to analyze visual subject matter and to use the appropriate reference tools, data standards, and vocabularies to describe them. Obviously, knowledge of the subject or material being classified is highly desirable. And, as I have stressed in this essay, the ability to work methodically and consistently is crucial.

To recapitulate, I believe that high-quality, thorough image cataloguing can be in four main stages:

- Slow down the cataloguer's mental processes in viewing the work of art, to ensure that it is being viewed in its entirety and not selectively
- Analyze the work of art in terms of overall subject matter and select a set of primary descriptive terms or keywords
- Catalogue the main visual elements, using a systematic approach to "reading" the work of art—left to right, right to left, top to bottom
- Determine and catalogue the meanings or symbolism in the subject matter as time, money, and expertise permit

It is important to keep in mind at all times what end-users could possibly want in an image and to attempt to classify those elements within a reasonable amount of time.

As long as a human element is involved in the cataloguing process—something that will remain with us for the foreseeable future—the role of the cataloguer is destined to be the most significant in the entire classification process. It is only by understanding this crucial aspect of the process that end-user access to images can be enhanced.

Notes

1. Cesare Ripa, *Iconologia,* ed. Piero Buscaroli, 2 vols. (Turin: Fògola, 1986). Thomas Heck's evaluations of subject access to images are among the most recent and include a section on Ripa; see Thomas F. Heck, ed., *Picturing Performance: The Iconography of the Performing Arts in Concept and Practice* (Rochester: Univ. of Rochester Press, 1999).

2. See, for example, Peter G. B. Enser, "Query Analysis in a Visual Information Retrieval Context," *Journal of Document and Text Management* 1, no. 1 (1993): 25–52.

3. On content-based image retrieval, see John P. Eakins and Margaret E. Graham, *Content-Based Image Retrieval: A Report to the JISC Technology Applications Programme* (January 1999), <http://www.unn.ac.uk/iidr/report.html>; Peter G. B. Enser, "Automatic Image Content Retrieval: Are We Getting Anywhere?" in Mel Collier and Kathryn Arnold, eds., *Electronic Library and Visual Information Research: Papers from the Third ELVIRA Conference, 30 April–2 May 1996* (London: Aslib, 1997), 123–35 <http://www.aslib.co.uk/pubs/2001/03/03.html>; and Venkat N. Gudivada and Vijay V. Raghavan, "Content-Based Image Retrieval Systems," *IEEE Computer* (Long Beach, Calif.) 28, no. 9 (1995): 18–22.

4. A useful study concerning the role of perception as regards visual material is E. H. Gombrich, Julian Hochberg, and Max Black, *Art, Perception and Reality* (Baltimore: Johns Hopkins Univ. Press, 1972).

5. ICONCLASS, which is touched upon by Sara Shatford Layne and more amply discussed by Patricia Harpring in this volume, is to my knowledge the most widely used subject classification system in art-historical image archives in North America and Europe. Among the recent publications focusing on the use of this system is Colum P. Hourihane, ed., *Image and Belief: Studies in Celebration of the Eightieth Anniversary of the Index of Christian Art* (Princeton: Index of Christian Art, in association with Princeton Univ. Press, 1999).

6. This is the French national system and is similar to ICONCLASS, but instead of using notations at the cataloguing level, it uses a thesaurus-type structure of vocabulary terms; see François Garnier, *Thesaurus iconographique: Système descriptif des représentations* (Paris: Léopard d'Or, 1984).

7. Unlike ICONCLASS, the Garnier system offers no options for variants on the traditional grouping of the Virgin, Saint Joseph, and the Christ child.

8. One of the best guides to understanding the approach used in this image archive is Helen Woodruff, *The Index of Christian Art at Princeton University: A Handbook* (Princeton: Princeton Univ. Press, 1942).

9. In addition, both singular and plural forms of nouns should be included as indexing terms, unless the end-user system or search engine allows for automatic truncation of words (which has both advantages and disadvantages) or otherwise handles this issue.

10. As is the case with the portrait by Jacopo Pontormo (see fig. 14) discussed by Patricia Harpring in this volume.

11. Michael Gorman and Paul W. Winkler, eds., *Anglo-American Cataloguing Rules,* 2d ed., 1998 rev. (Ottawa: Canadian Library Association; Chicago: American Library Association, 1998).

12. See Colum P. Hourihane, *Subject Classification for Visual Collections: An Inventory of Some of the Principal Systems Applied to Content Description in Images* (Columbus, Ohio: Visual Resources Association, 1999).

13. At the Index of Christian Art, a series of controlled subject terms (some 27,000 in number as of this writing) complements a free-text description, where controlled keywords are also used.

14. See Margaret E. Graham, *The Description and Indexing of Images: Report of a Survey of ARLIS members, 1998/99,* available at <http://www.unn.ac.uk/iidr/ARLIS>.

15. One example of the importance of color comes from the area of medieval art, where the use of yellow (on Jews' hats) or red (as in angels' wings) has recently been shown to be intentional, with a specific meaning. See Andreas Petzold, "'Of the Significance of Colours': The Iconography of Colour in Romanesque and Early Gothic Book Illumination," in Colum P. Hourihane, ed., *Image and Belief: Studies in Celebration of the Eightieth Anniversary of the Index of Christian Art* (Princeton: Index of Christian Art, in association with Princeton Univ. Press, 1999).

16. International Organization for Standardization, *ISO Standards Handbook I: Documentation and Information,* 3d ed. (Geneva: International Organization for Standardization, 1988).

17. See Graham, *Description and Indexing of Images.*

Pl. 1. Gerard Horenbout (Flemish, act. 1487–ca. 1520). *Death Scene* from the *Spinola Hours,*
MS Ludwig IX 18, fol. 184v. Ca. 1510–20, tempera colors, gold, and ink on parchment, leaf:
23.2 × 16.6 cm (9⅛ × 6⁹⁄₁₆ in.). J. Paul Getty Museum, Los Angeles

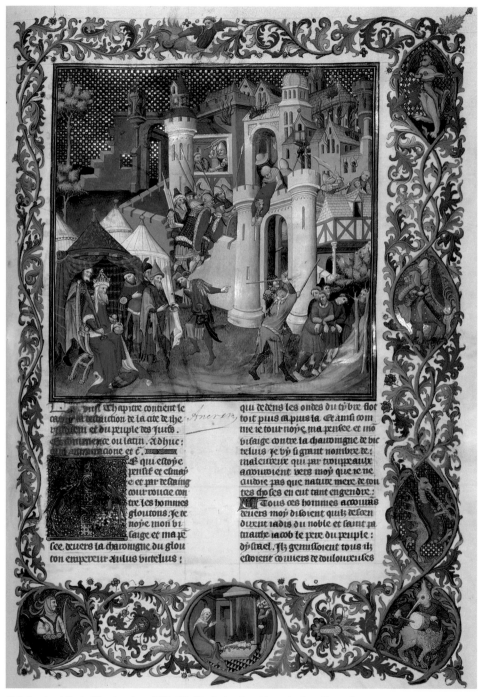

Pl. 2. Boucicaut Master (French, act. ca. 1405–20). *The Destruction of Jerusalem* from Giovanni Boccaccio, *Des cas des nobles hommes et femmes*, trans. Laurent de Premierfait, MS 63, fol. 237. Ca. 1415, tempera colors, gold leaf, gold paint, and ink on parchment, leaf: 42 × 29.6 cm (16⁹⁄₁₆ × 11¹¹⁄₁₆ in.). J. Paul Getty Museum, Los Angeles

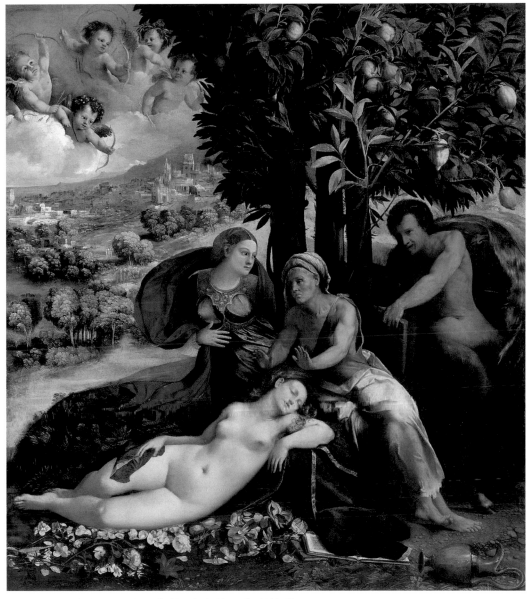

Pl. 3. Dosso Dossi (Italian, ca. 1490–1542). *Mythological Scene*. Ca. 1524, oil on canvas, 163.8 × 145.4 cm (64½ × 57¼ in.). J. Paul Getty Museum, Los Angeles

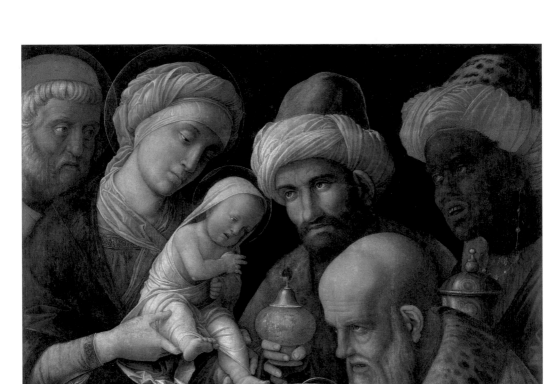

Pl. 4. Andrea Mantegna (Italian, ca. 1431–1506). *Adoration of the Magi.* Ca. 1495–1505,
distemper on linen, 48.5 × 65.6 cm (19⅛ × 25⅞ in.). J. Paul Getty Museum, Los Angeles

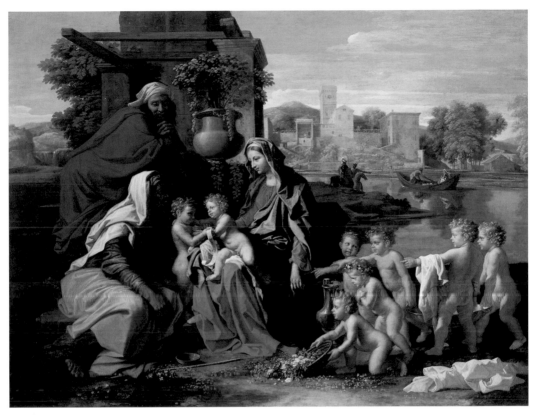

Pl. 5. Nicolas Poussin (French, 1594–1665). *The Holy Family.* Ca. 1651, oil on canvas, 100.6 × 132.4 cm (39⅝ × 52⅛ in.). J. Paul Getty Museum, Los Angeles

Pl. 6. Jan Steen (Dutch, 1626–79). *The Drawing Lesson*. Ca. 1665, oil on panel, 49.3 × 41 cm
(19⅜ × 16¼ in.). J. Paul Getty Museum, Los Angeles

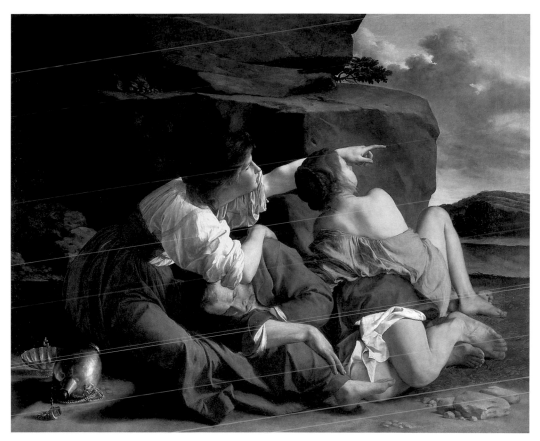

Pl. 7. Orazio Gentileschi (Italian, 1563–1639). *Lot and His Daughters*. Ca. 1622, oil on canvas,
151.7 × 189 cm (59¾ × 74½ in.). J. Paul Getty Museum, Los Angeles

J. Paul Getty Museum, Los Angeles

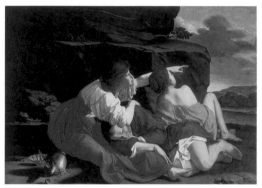

Museo Thyssen-Bornemisza, Madrid

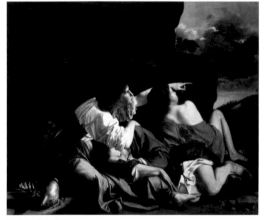

Gemäldegalerie, Berlin

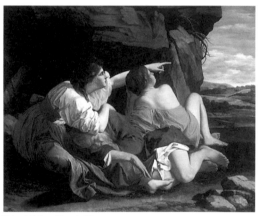

National Gallery of Canada, Ottawa

Pl. 8. Comparison of digitized color reproductions of four versions of Orazio Gentileschi's *Lot and His Daughters*

The Image User and the Search for Images

Christine L. Sundt
Curator and Professor, Visual Resources, Architecture and Allied Arts Library
University of Oregon, Eugene

An image seeker is a motivated user for whom needing a picture of something is the ultimate motivation. Time, or its absence, often dictates the urgency of the need. Cost is another factor: whether the image is worth the price, whether time is more precious than money. Some users know exactly what they want, while others are simply shopping for a good fit between an idea and its representation. How they communicate their needs, what obstacles they encounter in their quest, and how to help them avoid common pitfalls are some of the key points I address in this essay.

People look for images today as they always have, but they also look for them in new and different ways. This "then" and "now" dichotomy can be restated as traditional or manual access versus online or digital access. Traditionally, an image seeker—with or without a specific image in mind—began by browsing through books and magazines, using resources within reach with or without a specific image in mind. If the search through the materials at hand proved unsuccessful, the investigation would widen: with the help of a skilled reference professional, the user could find catalogues, published indexes, or vertical files where pictures were stored for the convenience of the information professional, and sometimes the user. Access systems for these files were largely idiosyncratic—conceived and constructed by whoever was in charge of the materials—because classification systems for pictures were, and for the most part are still, lacking uniformity and conformity to any standard. With the help of a resourceful information professional gifted with a photographic memory, homegrown finding aids, and a share of good luck, the searcher's needs could usually be fulfilled.

Today's digital environment offers new possibilities—and new challenges—for the image seeker under the guise of technology that seems to empower the end-user. By using the World Wide Web search engines or connecting to the many online sites specializing in art, architecture, and cultural heritage resources, users can browse through images without

going to a library or an image archive, or asking anyone for assistance. Remote access has its benefits, especially when a search can be undertaken at any time of the day or night, but ultimately the success of the search depends on the skills, knowledge, and luck of the seeker, and on how well the resources being searched have been constructed and indexed. Success can be achieved through this kind of "unmediated" research, but the chances of finding the best fit quickly and efficiently are often small. The results of some searches produce too many choices, or they may be incomplete and confusing.

With images playing a much greater role in our everyday lives than ever before, the user, even the experienced scholar, has to deal with many obstacles in the quest for an elusive image. The need for better avenues to image resources is still an unfulfilled dream for many. Over the past few decades, new tools have been created to assist with specialized terminology and complex subject descriptions, as described elsewhere in this book. These tools can take us a long way toward the goal of removing the language-based roadblocks, but only if they are implemented consistently by those who build information resources and utilized to their full potential by the user. The challenges for librarians, archivists, cataloguers, and developers of new tools that can assist users in accessing images are obvious:

- To create interfaces that accommodate and guide end-users through either or both simple and complex queries for both known and unknown images
- To build "knowledge bridges"—that is, to fill in the knowledge gaps between the user, the image, and the textual data used to describe the image
- To recognize the complexities that are often inherent in the "document-in-hand"—in most cases the image itself—in developing access points to that "document"

Anatomy of the Image User

We know something about users through studies, but regrettably we still lack enough information to know everything about their needs. We should more closely scrutinize our user logs to discover what our users are looking for and the words and phrases they are using in formulating their searches. From a study by Linda H. Armitage and Peter G. B. Enser, we know that users' needs have been neglected as an area of serious inquiry. We also know that there are noticeable similarities in how people formulate queries even across a range of image disciplines, and we are told that we can better serve the user by embedding analytical "schemas" within the information interface.[1]

Another study, published as *Object, Image, Inquiry: The Art Historian at Work,* solicited opinions from eighteen scholars "to represent a broad sampling of art historians active in research."[2] In the chapter entitled "The Process of Art-Historical Inquiry," regarding the relation between original works of art and reproductions, we learn that art historians are savvy image users who understand the vast differences that often exist between the object and its reproduction:

> The manipulative nature of reproductions and the relative merits and deficiencies of various media demand wariness. Nevertheless the practical difficulties of traveling to and comparing original works have produced ingenious methods of using reproductions of all kinds. As works of art and as records of conservation history, older photographs have special value. Collections of reproductions, whether institutional or personal, constitute vital resources for the art historian. The comprehensiveness of the collection, the inclusion of less well-known works, the scholarly acumen used in cataloging, and the difficulty of obtaining photographs were common preoccupations. Another was the absence of context that the photographic reproduction imposes on the work of art.[3]

The art historian's method of finding data is more a gathering process than anything else. Scholars collect data by "plowing through heaps of stuff" just "to find one particular piece of information." To them the process has its rewards: "you find out a lot of other things that you would never know you should know about."[4] The process of discovery, the looking and selecting, could sometimes prove to be more valuable than immediately retrieving a direct "hit."[5]

In general, scholars are well aware of the limitations of reproductions. In *Object, Image, Inquiry,* one said, "The work of art has a kind of object-hood and physical presence which is very different from any [reproductive] image; even if the slide or the transparency were perfect, it's third-best."[6]

Using Words to Look for Images

Users tend to approach an image search by specifying layers of information. However, they are generally unaware that they are actually setting up hierarchical relationships, and they often fail to understand why some methods work better than others in constructing a query.

- "I'm looking for a picture of a group"
- "I'd like it to be a family group"

- "This family should be doing something that would be typical for a family, like sitting around a table with food in front of them, looking grateful for what they have to eat"

The hierarchy in this query demonstrates a thought process that proceeds from a general concept—the group—to the specific concept—a family sharing a meal together. One example of such a family group might be Vincent van Gogh's *The Potato Eaters* (1885), in which a peasant family from the Dutch town of Nuenen, wearing traditional costumes of the time and place, are seated around a table.[7] The room in which they have gathered is dimly lit, illuminated only by the solitary oil lamp above them. Their humble meal consists of potatoes.

Keywords can help users formulate queries like those listed above for submission to an online search engine, but their effectiveness varies widely. The particular searcher's cultural background, education, and even verbal skills condition the choice of keywords used in an online search, not to mention his or her native language. Most objects and concepts can be described using multiple terms or phrases in many languages or dialects. If an end-user happens to use a keyword different from the one in the information system being searched, he or she may miss items that are actually there. As the authors of the other essays in this publication have shown, controlled vocabularies and thesauri can be enormously powerful tools for bridging these kinds of verbal gaps.

Even with accompanying texts or captions, images can still be difficult to locate. Captions that do not follow a good "tombstone" template (that is, artist, artist nationality and life dates, title, medium, creation date, repository) may describe the meaning or interpretation of the image but not state the facts about the artist or creator of the object represented in the image. Many images appear online without any reference to what they are or what they represent. Again, the other authors of this book have stressed how important indexing and cataloguing are in enabling end-users to find images by using keywords or textual strings.

Simplicity and common sense should be the guiding principles in finding solutions to assisting end-users:

- Know the needs of your users
- Employ simple yet effective user interfaces
- Err on the side of more rather than fewer access points
- Know what the tools employed to assist the user are designed to do, as well as their limitations
- Remember that what works in one situation may not be equally effective in another

The Quest

Consider for a moment where we see images. Much of our world looks different today, since television and computer monitors changed from monochrome to high color; since text phrases became icons; since books with few, mostly black-and-white images turned into richly illustrated color publications; and since our home printers began offering us the option of output in either black-and-white or color. These changes seem to have come about rather quickly, and yet some things have not changed at all. Consider now the challenge of finding a specific image or any image, an image of quality, an image that can be acquired for use without major limitations.

The search for the right image is still one of the more challenging exercises that users face, and perhaps more so since image use is at an all-time high. Thanks to technology, images are everywhere and seemingly available to everyone; image sites have sprung up all over the World Wide Web. The image may be ubiquitous, but the way we look for images today remains very much the challenge it was in the past. What might be even more alarming is the fact that finding the right image can also be more complicated now because, while we have much to choose from, our access resources and discovery skills are still quite primitive.

The Approach

In many instances, an image seeker has a preconceived idea of the desired image—a specific object or artwork, a place, a mood, a concept, a color, or a vision that is only a glimmer in the mind's eye. Finding a representation that fulfills the notion of the desire often takes time and skill. The searcher's success often depends on luck and perseverance.

"I'm looking for an image of …" is the usual starting point for this type of query. If the searcher can use well-crafted descriptive phrases and explain the nature of the needed image, then the results may be easier to obtain. Choosing the right words to describe the image and offering a context for the image or its use may provide useful starting points. The family seated around a table in van Gogh's painting might have been difficult to pinpoint unless some of the accessories were named. By adding keywords such as "potatoes," "lamp," "family," "eating," "meal," and "peasants," we can provide access via the main elements of *The Potato Eaters*.

We saw in Patricia Harpring's essay that an image of Herakles can be associated with a variety of themes: "Greek hero," "king," "strength," "fortitude," "perseverance," "labors," "Argos," "Thebes." In other words, this image can have many uses. Had the image of Herakles been indexed

with this array of search terms, the user would have no trouble finding it as long as one of the indexing terms was used in the search. It would not be necessary to remember the name Herakles—or its variant, Hercules—to bring results; the search would produce the image from any of the other terms associated with it.

Now suppose that a user wants an image of "labor." While the word seems specific enough, what matters to the user is *how* labor is represented. Looking for an image of "labor" is, therefore, not just a matter of locating a record that happens to include the term. The user may not want an image of Herakles' famed labors, but rather something having to do with the Labor Movement in post–World War I America—two very different subjects. This difference in the meaning and use of the term "labor" reflects the distinctions between the identification of the image and the interpretation of the subject, steps beyond the literal meaning of the term in its context, as noted in the other three essays in this volume.

If the user has a specific image of "labor" in mind, then the task can be more challenging when trying to find an equivalent to an elusive memory imprint from times past. So often we find that our memories are flawed; that what we remembered as one color was in reality another when we finally recovered the elusive object. How many times have you discovered that the blue book you were looking for actually had a red cover? Similarly, we may be remembering a detail of a whole, an image that apparently had sufficient power to stand on its own but does not warrant a unique identifier as a proper title. Conversely, without a fixed image in mind, the user is more open to choices. The right image emerges on the basis of "I'll know it when I see it." This could be the case with the user searching for an image to represent the Labor Movement. When none of the images retrieved shows the exact historical moment, the user finds that choosing another that conveys the spirit of the movement satisfies the need. Of course, if the end-user types in the keyword "labor" and the resource being searched uses the British spelling "labour" (or vice versa), relevant items could again be missed, unless a thesaurus that includes alternate spellings (as the *Art & Architecture Thesaurus* [AAT] does) is used or alternate spellings are included as indexing terms attached to the particular item.

Another option is to look for an image based on a title or written description that seems to include all the right elements for a perfect representation. How surprising when the words do not fit the picture—when the words actually have little connection to their meaning but are used to represent an abstract concept or to convey personal meaning. Robert Motherwell's series *Elegy to the Spanish Republic* exemplifies the distance between words and image in that the abstract columns and bulbous forms

rendered in stark contrast to each other—in many paintings from the series, black against a white field—are not taken from the facts of the Spanish Civil War but rather are a particular artist's reaction to the idea of human loss, resistance, and an ongoing struggle.[8] We can only know that the title does not illustrate a specific event in history by knowing the artist and his oeuvre, by knowing that Motherwell would not be a likely source for a factual illustration of a historical event.

So where does this leave the user and us in trying to locate an image? Obviously there are common pitfalls that snare a seeker of a particular image. How can these best be avoided?

Access Points

An image is more than a subject or a title. As the Motherwell example illustrates, it may be important to know something about the artist or the designer of the object depicted in the image. It may also be helpful to know when it was created, what the medium of the work is, who owns it, where it is located or displayed, the circumstances surrounding its making, how large it is, and whether it was ever altered. As Colum Hourihane points out in his essay in this volume, the two criteria employed by most online searchers appear to be subject matter and creator. These starting points are codified among several standard description tools used by museums and libraries, as summarized in the metadata standards crosswalk mentioned by Patricia Harpring.[9] One of these metadata standards, *Categories for the Description of Works of Art* (CDWA), has been used in examples elsewhere in this volume to show how subjects depicted in works of art are deciphered and described. But Subject Matter is only one element of a CDWA description. Its other core categories include Creator, Creation Date, Materials and Techniques, Measurements, and Current Location (see the CDWA record for a Panathenaic amphora on page 29).

Not every work can be described to the extent outlined in CDWA (nor would this necessarily even be desirable were it practical), but any data that follow a standard description format, where controlled vocabulary or terminology can be applied, are ultimately more accessible than data that do not adhere to any standards or vocabulary control. The value of the data are still largely conditioned by the skill of the indexer and the rules governing the data entry process, however. As Hourihane has argued, not all cataloguing and indexing are equal; nor are all data records complete or even correct.

Nonetheless, a descriptive record that includes only the title or description of a work may not be sufficient for providing access to its image. More promising would be, for example, a record that includes a

date or time span that puts the title into a historical context and then adds information about its medium to help differentiate between works that are two- and three-dimensional.

Size or scale can also be valuable in helping to differentiate works bearing the same title, by the same artist, of the same date and medium, where one is likely a smaller model from which the larger finished work was created. Another useful element is the current location or ownership information about the work. With this information, the user is equipped with names and places: where to go for more information about the object, where it can be viewed, or where and how to obtain a reproduction of it.

A Case in Point

Searching for an image of *Lot and His Daughters,* a biblical subject (Genesis 19:30–38), one finds that the seventeenth-century Italian artist Orazio Gentileschi painted not one but at least five finished versions of this theme. One of these, dated to 1622, is in the collection of the J. Paul Getty Museum (pl. 7).

The Getty's picture shows a sleeping man, Lot, dressed in a blue garment, between two women, his daughters. The sisters' gazes and gestures lead us toward the right side of the canvas, to an event happening in the distance. They sit in front of a dark rock, presumably the cave where they and Lot had taken refuge, with their backs mostly to the viewer, one more in profile than the other. To the left of the daughter in profile are metal vessels, one a silver flask on its side, open and apparently empty, and the other a golden cup. These "props," in combination with the figures in this setting, are keys to the iconography of the painting.

Both women wear garments, but the one on the viewer's right and farther to the back is shown with bare skin, where her dress has fallen off her shoulders. The background includes ominous clouds and a bright glow above the distant hills. The glow obviously refers to the fire consuming the cities of Sodom and Gomorrah from where they had fled, but not before Lot's wife was punished for looking back as they were leaving. Lot's daughters, believing that they were the last human beings to remain on earth, have made their father drunk prior to sleeping with him—to save the human race. This portrayal of incest was popular in Gentileschi's time because of the artistic and erotic liberties it offered artists and their patrons. In the Getty's version, the daughter on the viewer's left wears a red garment over a white shirt; her sister is clad in a golden yellow chemise.

A second work by Gentileschi bearing the same title is in the Gemäldegalerie in Berlin (see pl. 8). The main difference between this work and the Getty's picture is that the colors of the daughters' garments

are reversed: the daughter in profile wears a golden yellow dress and the one on the right is dressed in red.

Another version, now in the National Gallery of Canada/Musée des beaux-arts du Canada in Ottawa (see pl. 8), was purchased in 1965 from the Spencer Churchill collection in London. The colors of the daughters' garments are similar to the Getty's version, but the metal objects in the foreground are missing. Also, the background sky and landscape seem less ominous, the burning city is missing, and the overall contrast of light and dark (chiaroscuro) is understated compared to the other examples. The cave behind the family group is larger and rounder than in the other paintings, and the foreground rock cluster shows smoother edges and larger masses as well. Finally, where the foliage growing among the rocks in the other examples is alive and bushy, in this version it is a just a branch, devoid of leaves.

A fourth version is part of the Fundacion Colección Thyssen-Bornemisza in Madrid (see pl. 8). In some sources, the painting is said to be located in Castagnola or Lugano, not in Madrid, but still owned by Thyssen-Bornemisza. The daughters' garments follow the color pattern in the Getty's version. Data recorded in a sampling of contemporary literature about these four versions of Lot and His Daughters are presented in the table on page 76.[10]

There is a fifth version under this title, also oil on canvas. The largest in the group, measuring 226 × 282.5 cm, it is held by the Museo de Bellas Artes, Bilbao (fig. 20),[11] This last work, signed by the artist and dated by scholars to 1628, shows a different arrangement of the daughters and their father, as well as the setting, inside rather than outside the cave, so it is chiefly related to the other four versions by its title and creator.

The Flemish artist Lucas Vorsterman (1595–1675) made an engraving of the Bilbao version, the plate presumably produced under Orazio Gentileschi's supervision in London sometime in the 1630s. The print, a reverse of the painted image, measures 332 × 430 mm and is in the collection of the British Museum in London.[12] Vorsterman's engraving is just one of many copies and reproductions made by artists after the Bilbao and other versions of Gentileschi's composition.

Why So Many Versions?

It may be comforting to know that if one needs an image of Lot and His Daughters, there are at least five paintings by Orazio Gentileschi and many copies after his work to choose from. Perhaps any of the versions will suffice, but it may be beneficial to have options. It also may be a source of confusion, given what we have discovered about this composition and its scholarly sources.

Collection	Title	Date	Dimensions	Source
Los Angeles, J. Paul Getty Museum (98.PA.10)	Lot and his daughters	ca. 1622	59¾ × 74½ in. (151.7 × 189 cm)	<http://www.getty.edu/art/collections/objects/o116389.html> (color illus.)
	Lot and his daughters			Bissell, *Orazio Gentileschi and the Poetic Tradition in Caravaggesque Painting* (monochrome illus., no. 102; mistakenly identified as pre-restoration no. 47)
Berlin, Gemäldegalerie (2/70) [Berlin, Dahlem Museum; Berlin-Dahlem, Staatliche Gemäldegalerie]	Lot und seine Töchter	um 1622/23	164 × 193 cm	*Gemäldegalerie Berlin: Gesamtverzeichnis der Gemälde: Complete Catalogue of the Paintings* (p. 34; monochrome illus., no. 1393)
	Lot and his daughters		164 × 195 cm	<http://www.saskia.com/query/Selected_Work.asp?WorkID=3152> (text only). Saskia Ltd. Cultural Documentation, color slide no. Mif-0823
	Lot and his daughters		169 × 193 cm	Nicolson, "Orazio Gentileschi and Giovanni Antonio Sauli" (monochrome illus., fig. 11; detail, fig. 13)
	Lot and his daughters	ca. 1622	1.64 × 1.93 m	Bissell, *Orazio Gentileschi and the Poetic Tradition in Caravaggesque Painting* (cat. no. 48; monochrome illus., no. 104; detail, no. 106)
Ottawa, National Gallery of Canada / Musée des beaux-arts du Canada (14811)	Loth et ses filles	v. 1621–24	157.5 × 195.6 cm	<http://cybermuse.gallery.ca/ng> (color illus.)
	Lot and his daughters		157.5 × 195.6 cm	Nicolson, "Orazio Gentileschi and Giovanni Antonio Sauli" (monochrome illus., fig. 12; detail, fig. 14)
	Lot and his daughters	ca. 1624	157.5 × 195.6 cm	Finaldi, *Orazio Gentileschi at the Court of Charles I* (color illus., fig. 7)
	Lot and his daughters	ca. 1624	1.575 × 1.956 m	Bissell, *Orazio Gentileschi and the Poetic Tradition in Caravaggesque Painting* (cat. no. 53; monochrome illus., no. 105)
	Loth e le figlie			*Orazio Gentileschi* (color illus., pls. xiv, xv)
Madrid, Museo Thyssen-Bornemisza (155) [Castagnola, Sammlung Thyssen-Bornemisza; Lugano, Thyssen-Bornemisza Collection]	Lot y sus hijas	ca. 1621–23	120 × 168.5 cm	<http://www.museothyssen.org> (color illus.)
	Lot y sus hijas	1621		<http://www.artehistoria.com/genios/cuadros/5267.htm> (color illus.)
	Lot and his daughters		120 × 168 cm	Miniature Gallery (Oxshott, Surrey), Thyssen-Bornemisza: Old Masters slide set, color slide no. 28 [in Lugano]
	Lot and his daughters		120 × 168.5 cm	Finaldi, *Orazio Gentileschi at the Court of Charles I* (color illus., cat. no. 5) [in Madrid]
	Lot and his daughters	ca. 1621	1.20 × 1.685 m	Bissell, *Orazio Gentileschi and the Poetic Tradition in Caravaggesque Painting* (cat. no. 47; monochrome illus., no. 103) [in Castagnola]
	Lot and his daughters		120 × 168.5 cm	<http://www.umich.edu/~hartspc/umsdp/TBM.html> (text only). University of Michigan, Thyssen-Bornemisza Collection: Old Masters slide set, color slide no. TBM 071 [in Lugano]

Why would an artist paint more than one picture of the same subject? It may be that the image was popular and several of the artist's patrons wanted copies. Or it may be that the patron was dissatisfied with one version and wanted something changed, which resulted in another painting, or several more, before the patron was happy with the commission. Still another reason might be that some of the works are by followers or students of the artist—"practice pieces" from a later date. In this example, all five paintings are believed to be by Orazio Gentileschi himself.

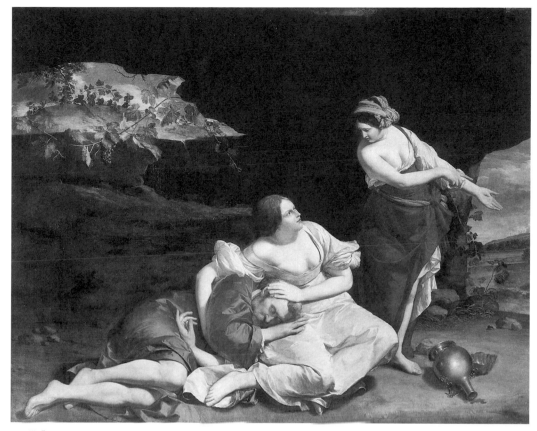

Fig. 20. Orazio Gentileschi (Italian, 1563–1639). *Lot and His Daughters* 1628, oil on canvas, 226 × 282.5 cm (89 × 111¼ in.). Museo de Bellas Artes, Bilbao

Only a careful study of all the facts known about a work of art will bring an informed answer. This type of study relies largely on a combination of the verity of information that accompanies an image of the work and a careful analysis of the work itself—looking at the condition of the paint, how the paint was applied to the surface, how the support was constructed, whether the work shows signs of alterations (sections or pieces added or removed), and, perhaps of greatest value, the history of the work's ownership, its "pedigree" or provenance. CDWA facilitates the collection of all these facts in a consistent and orderly manner so that someone studying the work will find rich, interrelated data associated with the object. But even scholars are sometimes mistaken by evidence in hand.

Titles

The artist sometimes assigns a title to a work of art or architecture, but a curator or scholar who has carefully studied the work often assigns it after the fact. How titles are assigned and what they mean in providing access

to a work of art are issues discussed elsewhere in this book and at considerable length in CDWA. We know from the Gentileschi composition that the figures, setting, and props contributed to our identification of the iconography as belonging to the story of Lot from the Old Testament. In looking for an image of an object or artwork, we must take into account the fact that titles can vary, especially if there is a question about the subject matter.

In the Gentileschi examples, all the works bear the same title, even though one painting shows a different arrangement of elements and personages. The same applies to Motherwell's series, where all the images are named *Elegy to the Spanish Republic* but each shows a different composition. A good example of a single work with drastically different titles is Rembrandt's famous painting, *The Night Watch* (1642; Amsterdam, Rijksmuseum).[13] We now know that a better title for the painting is *The Militia Company of Captain Frans Banning Cocq.* Still another title might include the names of the various people depicted in the scene.

The title *The Night Watch,* in fact, was given to this work because of the somewhat dark varnish that once covered the painting's surface; the scene looked to be happening under the cover of night. Once the painting was cleaned and studied again, more facts emerged, requiring that a new title be assigned. Since the change occurred relatively recently (during the 1940s), most of the literature refers to the painting as *The Night Watch.* Thus, it is perfectly plausible that an image in a publication dating from the 1930s would be identified only with the old title. Without knowing more about the work and its alternate title, a person looking for an image may miss a valuable cache of reproductions and information, disconnected by time from the more recent research about the same work of art.

The guidelines given in CDWA accommodate and even encourage the inclusion of alternate titles and names. The indexer should seek out as many title variations as possible when describing a work of art and use tools that bring these variables together. Structured vocabularies and thesauri such as the ones discussed at length in the other essays in this volume were specifically designed to address the problem of variable terms and names for objects, media, creators, and places, and to assist the cataloguer in creating relationships among the variants. Structured vocabularies and thesauri, such as the Library of Congress's *Name Authorities* and the AAT, are useful for some aspects of subject description (usually those not dealing with strictly narrative or iconographic content), but a tool such as ICONCLASS is necessary for describing the narrative or iconographic meaning of works of art. As demonstrated by Harpring and Hourihane in their essays, a system like ICONCLASS—or a carefully constructed local authority file of subjects—can be used to create hierarchical relationships among iconographic themes or narrative episodes. It can also

be used to make connections among images with similar compositions, where figures are grouped in a like manner or where accessories, furnishings, and props appearing in the work are identical. For example, even though the metal vessels are missing from the National Gallery version of *Lot and His Daughters,* the composition would be linked to the others in the series because of other compositional similarities. Properly analyzed and described in this way, two seemingly unrelated works can be reunited, or one work based closely on another can be recognized.

Measurements and Dimensions

At least three versions of Gentileschi's *Lot and His Daughters* are closely related not only via their titles and compositions but also by their dimensions. In addition to variations among versions, researchers should note whenever a single work in the group has been described with different measurements. The variation may be due to conversion between inches and metric measurements or because one person measuring the work took the numbers from inside the frame (so-called sight measurements), while another measured the canvas with the frame removed. One person may measure rounding off numbers, while another is more precise.

Measurements can be misleading in other ways as well. Some prints (engravings, etchings, and aquatints, for example) are measured to record the size of the plate from which the impression or relief was taken, while others record the measurements of the full sheet of paper carrying the print. Sculpture measurements can vary as well. Height can be determined by measuring a statue or object with or without its base or pedestal. In the case of ancient sculpture, heads often are reattached to torsos at a later time. The measurements of a statue may include later additions, and sometimes even restored parts. Measurements should be used with caution in critical comparisons or when trying to prove that two works of art are the same or different.

Dates and Dating

The four analogous Gentileschi images have been assigned similar dates, between 1621 and 1624, but the artist himself dated none of them. Many dates, or perhaps none at all, can be associated with a work of art or architecture. Attempting to find an image based on the date of an object might be difficult unless that date is highly significant to the work of art. Sometimes even dates that appear on the work are suspect; they could have been added by a later hand or included to refer to an event preceding the creation of the work. Scholars who have spent considerable time reconstructing an artist's oeuvre, making distinctions between the artistic styles

of one expressive period and another, often assign dates. Perhaps some of the more remarkable dates can be found in the dating of Greek pottery, especially works of Attic origin. For these works, artists are assigned names, for example, the Meleager Painter,[14] and their styles are placed within a chronological construct that defines the birth, adolescence, maturity, and ultimate decline of this art form. Few works within this construct are firmly dated or even signed, but the literature is rich in seemingly precise dates. Some of the more difficult areas to define according to date are Etruscan art and the artifacts of native tribal cultures. Nevertheless, dates or date ranges are often given simply as a way of differentiating one style or period from another.

Location, Location!

Many works of art have the potential to be mobile. Even a fresco that was originally part of a narrative or decorative cycle and affixed to a wall can find its way into a museum and be displayed as an independent work.[15] Entire buildings can be housed within a museum; for example, a Maori tribal house is now in the Field Museum of Natural History in Chicago, thousands of miles away from its original location in New Zealand.

The popularity of eBay and art auctions is not a new phenomenon. Works of art and other artifacts move now, as in the past, from one owner to another at the drop of a hammer (or click of a computer mouse). The literature about the Gentileschi paintings demonstrates that the works have had many owners. Some owners housed their collections in different cities (Lugano, Castagnola, and Madrid); and scholars, even after careful analysis, can disagree on the exact pattern of ownership for some works. Three of the four versions of *Lot and His Daughters* were acquired by their current owners since the 1960s, so even some fairly recent literature includes references to former owners. A case in point is the Ottawa version, which was housed in the Spencer Churchill collection in London prior to being purchased in 1965 by the National Gallery of Canada. Often it is possible to link a work to an earlier reference by comparing its physical features (measurements, surface blemishes, and so on), as well as closely inspecting any available reproductions. However, an image can be deceptive and untrustworthy, too, as we saw in the art historian's warning about reproductions quoted at the beginning of this essay (see p. 69).

A work shown only in black-and-white or monochrome reproductions can be misleading, since subtleties of color are lost. In a catalogue raisonné of Gentileschi's work, the canvas now owned by the Getty was misidentified as the Thyssen-Bornemisza version because when two

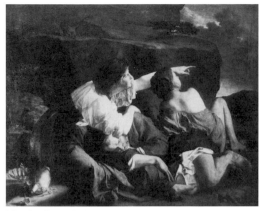

J. Paul Getty Museum, Los Angeles

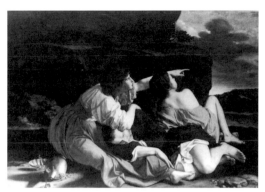

Museo Thyssen-Bornemisza, Madrid

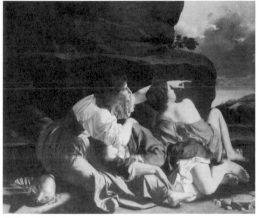

Gemäldegalerie, Berlin

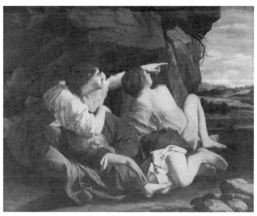

National Gallery of Canada, Ottawa

Fig. 21. Comparison of published black-and-white reproductions of four versions of Orazio Gentileschi's *Lot and His Daughters*

black-and-white reproductions were compared, they appeared to be the same work (fig. 21).[16] The differences that could be perceived were thought to be the result of restoration—one showing the painting before restoration, the other after. In reality, the photograph shows yet another version, the Getty's, not included in the catalogue raisonné.[17]

The analysis was further hampered by the fact that the subtle differences between the colors of the daughters' garments—reddish on the left and golden yellow on the right in the Getty, Thyssen-Bornemisza, and National Gallery versions, but the reverse in the Gemäldegalerie painting—are not immediately visible in the monochrome reproductions. Users unaware of these color variations might not realize that this important distinction exists, or they might not realize that reproductions can be inaccurate due to the photographic process and the limitations of early black-and-white film in rendering color.[18]

Color reproductions can be equally misleading. The same work of art shown in two color illustrations can look entirely different if the overall color balance is off. In sum, judgments based on the examination of reproductions rather than the study of the actual work can lead to false conclusions. Image seekers should be warned about drawing assumptions based on reproductions. Indeed, even the best may only be "third rate."

Again with regard to location, architectural elements have moved from one place to another throughout history. The famous Elgin Marbles, now in the British Museum in London, were removed from their original location on the Parthenon in Athens in the early nineteenth century. Before the invention of photography in the 1830s, pictorial records in the form of paintings, drawings, and prints provided evidence regarding the location and condition of works of art and architecture. For these non-photographic types of reproductions, artistic license and the skill of the artist who created a particular image played an important role in whether the rendition was ultimately accurate.

Another phenomenon is the changing of data about the location itself. National borders change due to political events, and countries take new names to reflect a new regime or newfound independence. Tools such as the *Getty Thesaurus of Geographic Names* enable us to link former names with a modern one (for example, Lisbon was called *Ulixbone* under Moorish rule, and *Felicitas Julia* under the Romans; the name *Persia* was officially changed to *Iran* in 1935, but it also refers to a region of what is now Southern Iran, known as *Parsa,* inhabited by Indo-European people around 1000 B.C.E.) and to reference geographic entities that no longer exist in the modern political world (for example, Etruria, Flanders, Holy Roman Empire, Phoenicia). Cities are also subject to remodeling, renaming, and annexation. Streets often have more than one name in use and

perhaps several more buried in earlier directories. Buildings referenced by a street address must be studied in their historical and political contexts. Buildings, too, change over time. Consider the Louvre in Paris, with its various incarnations from fortress to palace to museum, and the many architects who contributed to its forms.

The Sum of Many Parts

Given the obstacles described above, locating a specific image can involve a considerable amount of work, even for an image seeker with considerable knowledge. Even when the object in question has a title, that title may not be an accurate reflection of content, as in the Motherwell example. A title may point to many works that are similar yet different enough to make selection of one difficult, as in the versions of Gentileschi's *Lot and His Daughters*. The date assigned to a work may be misleading, and the artwork or object may have been moved several times. The dimensions can vary from one source to another, seeming to suggest that the work must be a different one when in fact it is the same. An image without any accompanying descriptive data is virtually useless, however. Finally, the quality of the image—how accurately it is represented by its illustration—is an important factor in deciding whether to use a particular image.

The researcher or image seeker must know how to judge and balance the facts associated with a picture. Vocabulary tools and classification systems such as the ones discussed in the preceding essays provide valuable assistance in sorting through questions having to do with names, terms, and iconography. How well these tools are used in creating descriptive records becomes the deciding factor in the end. The more the cataloguer or indexer can do to facilitate access —through standards, common tools, and shared strategies—the easier it is for the searcher to find what is needed, be it one image or many. A picture may be worth a thousand words, but one hopes that the words themselves have value for the image seeker as well.

Notes

1. Linda H. Armitage and Peter G. B. Enser, "Analysis of User Need in Image Archives," *Journal of Information Science* 23, no. 4 (1997): 287–99.

2. Marilyn Schmitt, gen. ed., *Object, Image, Inquiry: The Art Historian at Work: Report on a Collaborative Study by the Getty Art History Information Program and the Institute for Research in Information and Scholarship* (Santa Monica, Calif.: Getty Art History Information Program, 1988), 3. Other studies worthy of mention for their contributions to our understanding of users are Valerie J. Bradfield, *Slide Collections: A User Requirement Survey* (Leicester: Leicester Polytechnic,

1976); and Michael Ester, "Image Quality and Viewer Perception," *Visual Resources* 7, no. 4 (1991): 327–52. How people learn about and remember well-known artworks was studied by Helene Roberts and reported in "Second-Hand Images: The Role of Surrogates in Artistic and Cultural Exchange," *Visual Resources* 9, no. 4 (1994): 335–46.

3. Schmitt, *Object, Image, Inquiry,* 22.

4. Schmitt, *Object, Image, Inquiry,* 35.

5. This is similar to what Marcia Bates refers to as "berrypicking"; see Marcia J. Bates, "The Design of Browsing and Berrypicking Techniques for the On-Line Search Interface," *Online Review* 13, no. 5 (1989): 407–24.

6. Schmitt, *Object, Image, Inquiry,* 7.

7. Images of this particular work seem to be ubiquitous on the World Wide Web; see, for example, the Vincent van Gogh Gallery <http://www.vangoghgallery.com/painting/p_0082.htm>.

8. See, for example, <http://www.guggenheimcollection.org/site/artist_work_md_1161.html>.

9. See this document at <http://www.getty.edu/research/institute/standards/intrometadata/3_crosswalks/index.html>.

10. Illustrations and documentation for this sample survey can be found in the following publications: R. Ward Bissell, *Orazio Gentileschi and the Poetic Tradition in Caravaggesque Painting* (University Park: Pennsylvania State Univ. Press, 1981); Gabriele Finaldi, ed., *Orazio Gentileschi at the Court of Charles I,* exh. cat. (London: National Gallery, 1999); *Orazio Gentileschi,* I Maestri del Colore 83 (Milan: Fratelli Fabbri, 1965); B. Nicolson, "Orazio Gentileschi and Giovanni Antonio Sauli," *Articus et historiae* 12 (1985): 9–25; David Ekserdjian, *Old Master Paintings from the Thyssen-Bornemisza Collection,* exh. cat. (Milan: Electa; London: Royal Academy of Arts, 1988); and *Gemäldegalerie Berlin: Gesamtverzeichnis der Gemälde: Complete Catalogue of the Paintings* (London: Weidenfeld & Nicolson, 1986).

11. Color illustration in Finaldi, *Orazio Gentileschi at the Court,* 67 (cat. no. 7).

12. Illustrated in Finaldi, *Orazio Gentileschi at the Court,* 66 (cat. no. 7), fig. 34.

13. See illustration at <http://www.hollandmuseums.nl/uk/info/faq1.html>.

14. See the information online for this artist and the volute krater attributed to him in the collection of the J. Paul Getty Museum, inv. no. 87.AE.93, at <http://www.getty.edu/art/collections/bio/a772-1.html>.

15. Sandro Botticelli's *Venus and the Graces Offering Gifts to a Young Girl* (ca. 1483), originally in the Villa Lemmi near Florence, is an example of a painting taken "out of context" and seen by millions of visitors to the Musée du Louvre, Paris.

16. Bissell, *Orazio Gentileschi and the Poetic,* 174.

17. Compare figures 102 and 103 in Bissell, *Orazio Gentileschi and the Poetic;* the difference in the shadow pattern created by the metal vessels in the lower left foreground links Bissell's figure 102 with the Getty's version.

18. See "Documents in the History of Visual Documentation: Bernard Berenson on Isochromatic Film," *Visual Resources* 3, no. 2 (1986): 131–38; and Thomas Moon, "The Original in Reproduction," *Visual Resources* 5, no. 2 (1988): 93–104, esp. figs. 5, 6.

Annotated List of Tools

Art & Architecture Thesaurus (AAT)

<http://www.getty.edu/research/tools/vocabulary/aat>

A structured vocabulary that contains terminology and other information related to art, architecture, and related disciplines. Updated monthly.

Categories for the Description of Works of Art (CDWA)

<http://www.getty.edu/research/institute/standards/cdwa>

A metadata schema that describes a set of categories and recommendations that may be used to design information systems and to catalogue art, architecture, and related materials, including archaeological and archival materials.

Getty Thesaurus of Geographic Names (TGN)

<http://www.getty.edu/research/tools/vocabulary/tgn>

A structured vocabulary that contains names and other information about geographic places; it is focused on, but not limited to, places important to art, architecture, and related disciplines. Updated monthly.

Graphic Materials

Betz, Elisabeth W., comp. *Graphic Materials: Rules for Describing Original Items and Historical Collections.* Washington, D.C.: Library of Congress, 1982.

A set of rules for the descriptive cataloguing of prints, photographs, and other graphic materials. Does not include rules for subject cataloguing and classification. Compatible with the second edition of the *Anglo-American Cataloguing Rules* (AACR2), which is widely used in libraries for the descriptive cataloguing of books and other materials.

ICONCLASS

<http://www.iconclass.nl>

Waal, Henri van de. ICONCLASS: *An Iconographic Classification System.* 9 vols. in 17. Completed and edited by L. D. Couprie with R. H. Fuchs, E. Tholen, G. Vellekoop, and others. Amsterdam: North-Holland, 1973–83.

Straten, Roelof van. *Iconography, Indexing, ICONCLASS: A Handbook.* Leiden: Foleor, 1994.

A classification system for iconographic research and documentation of images; ICONCLASS offers ready-made definitions for objects, persons, events, situations, and abstract ideas that can be represented in the visual arts. The system is organized in ten broad divisions within which subjects are ordered hierarchically.

Library of Congress's Name Authorities

Library of Congress. *Name Authorities.* Cumulative microform ed. Washington, D.C.: Library of Congress, Cataloging Distribution Service.

Library of Congress. *Name Authorities.* Database ed. Washington, D.C.: Library of Congress, Cataloging Distribution Service.

A controlled vocabulary consisting of records for names and series established by the Library of Congress and cooperating libraries under the National Coordinated Cataloging Operations (NACO) program. Available as a computer file or in microfiche through the Library of Congress; also made available in electronic form by various vendors. When made available separately, it is sometimes called *Library of Congress Name Authority File* (LCNAF); when made available in conjunction with *Library of Congress Subject Headings* (LCSH), it is sometimes called *Library of Congress Authority File* (LCAF).

Library of Congress Subject Headings (LCSH)

Library of Congress. Cataloging Policy and Support Office. *Library of Congress Subject Headings.* Washington, D.C.: Library of Congress, Cataloging Distribution Service.

Library of Congress. Cataloging Policy and Support Office. *Subject Cataloging Manual: Subject Headings.* 5th ed. Washington, D.C.: Library of Congress, Cataloging Distribution Service, 1996.

A structured vocabulary designed to represent the subject and form of the books, serials, and other materials in the Library of Congress collections, with the purpose of providing subject access points to the bibliographic records contained in the Library of Congress catalogues. More broadly, LCSH is used as a tool for subject indexing of library catalogues and other materials (including visual materials). Available in print (annual) and microfiche (updated quarterly). Also available on line from various vendors and bibliographic utilities, and as part of the Library of Congress CD-ROM product *Classification Plus.*

Subject Index for the Visual Arts

Glass, Elizabeth, comp. *A Subject Index for the Visual Arts*. London: H. M. Stationery Office, 1969.

A structured vocabulary used for subject access to materials in the Print Room of the Victoria and Albert Museum, London.

Thesaurus for Graphic Materials (TGM)

Library of Congress. Prints and Photographs Division. *Thesaurus for Graphic Materials*. Washington, D.C.: Library of Congress, Cataloging Distribution Service, 1995.

Thesaurus for Graphic Materials I: Subject Terms. <http://www.loc.gov/rr/print/tgm1>.

Thesaurus for Graphic Materials II: Genre and Physical Characteristic Terms. <http://lcweb.loc.gov/rr/print/tgm2>.

A structured vocabulary containing terms that describe both the subjects and the object/work types of graphic materials. First issued in print as two separate works, *LC Thesaurus for Graphic Materials* (1987) and *Descriptive Terms for Graphic Materials* (1986). The online version continues to be separated into two parts, one containing subject terms (TGM I) and one containing object/work type terms (TGM II).

Thesaurus Iconographique

Garnier, François. *Thesaurus iconographique: Système descriptif des représentations.* Paris: Léopard d'Or, 1984.

A structured vocabulary for the subjects of images. In French.

Union List of Artist Names (ULAN)

<http://www.getty.edu/research/tools/vocabulary/ulan>

A structured vocabulary containing names and other information for artists, architects, and other creators of art and architecture. Updated monthly.

VRA Core Categories

<http://www.vraweb.org/vracore3.htm>

A metadata schema for describing visual documents depicting works of art, architecture, and artifacts or structures from material, popular, and folk culture. Based on *Categories for the Description of Works of Art*.

Glossary

about-ness

An expression used in the context of subject description to refer to thematic or symbolic meaning intended by a work of art. *About-ness* corresponds to Erwin Panofsky's *interpretation,* the third level of subject description specified in *Categories for the Description of Works of Art.* For example, "The Medusa has been interpreted as a symbol of everything from the female mysteries to the creativity and destruction inherent in Nature. A more recent manifestation is the character played by Glenn Close in the 1987 film *Fatal Attraction,* where the Medusa figure is seen as the devourer and potential destroyer of men." Compare *of-ness.*

access point

A database field or metadata category (for example, Title, Subject, Creator) designed to be searchable and retrievable by an end-user, as distinguished from information that is intended primarily for display. Compare *display data.*

algorithm

A formula or set of steps devised to solve a particular problem. In an automated environment, an algorithm is a set of rules, expressed in programming language, to accomplish a particular task.

associative relationship

In a thesaurus, a link to a concept peripherally related to the concept at hand. For example, *arriccio* and *intonaco* (types of plaster) are linked to *fresco* (a type of wall painting) in the AAT via an associative relationship rather than a *hierarchical* or *equivalence relationship.*

authority (*also called* authority file)

A file or set of terms extrinsic to the object or document being described. When used for retrieval, this file or set of terms is more efficiently recorded in separate linked files rather than in individual records about the object itself. The advantage of storing ancillary information in an authority is that this information needs to be recorded only once, as it may then be linked to all appropriate object/work records. An authority record typically contains the preferred name or term for a particular concept, as well as synonyms and additional information.

authority control (*also called* vocabulary control)

The process of governing the form and content of information in an object record, including proper names and other terminology, typically by requiring the use of designated syntax or a *preferred term,* with the goal of ensuring that all citations and references to a given subject or concept are the same. See also *controlled vocabulary.*

Boolean operators

Specific methods of logic, syntax, and terms used in programming and retrieval in databases to manipulate TRUE/FALSE values. For example, "SELECT term FROM term table WHERE value LIKE "Magi" OR ("Three" AND "Kings") OR ("Wise" AND "Men")." In this example, the query is asking for all records with the words "Magi" or "Three Kings" or "Wise Men" but only if the words "King" and "Men" are part of text strings that include the words "Three" and "Wise." Boolean operators, originally formulated in 1847 by George Boole of England, are derived from the symbolic system of mathematical logic that represents relationships among entities.

cataloguing

The process of recording information about a work of art or architecture and/or its visual surrogate, usually including a systematic description, subject analysis, and the assignment of a classification notation and/or terms from one or more vocabularies.

content-based image retrieval (CBIR)

A computer technique for retrieving images based on automatically derived features such as color, texture, and shape.

controlled vocabulary

An established list of terms from which an indexer or cataloguer may select when assigning descriptors or subject headings to a record representing a work. See also *authority control.*

crosswalk

A chart or table that represents the semantic mapping of fields or data elements in one metadata schema to fields or data elements in one or more other metadata schemas. Crosswalks make it possible to search heterogeneous information resources simultaneously with a single query as if they were in a single system (*semantic interoperability*), and to convert data from one metadata schema to another. See also *metadata mapping.*

data structure

The interrelationships of information in a database or information system. At the broadest level, *data structure* includes definitions of entire entities or files, the relationships among entities, the categories or attributes that define the entities, and the relationships of categories to other categories. Examples of database structures include the *flat file structure* and the *relational file structure*.

decorative arts

Artworks that serve utilitarian as well as esthetic purposes, typically involving the decoration and embellishment of household utilitarian objects, including furniture and eating utensils.

descriptive metadata

Metadata used to describe or identify an information object or information resource.

display data

Data that are typically intended to be read as part of a record that has been retrieved by an end-user; not necessarily subject to terminology control, and not intended for use in retrieval. Compare *access point*.

entity

A thing of significance—something distinct or self-contained—about which information needs to be known, recorded, or stored. *Entity* may also refer to principal conceptual entities in an information system, whether or not they are actually reflected in the database structure. To a cataloguer, a corporate body—that is, any group of people working together, not necessarily a legally incorporated *entity*—is considered an entity. In another sense, a record in a catalogue is *metadata* about the *entity* it describes.

equivalence relationship

The one-to-one relationship between concepts that are equal, as, for example, the relationship between terms or names that represent the same concept in a thesaurus, as *truck* (U.S.) and *lorry* (U.K.).

field

A basic unit of a record, typically a space reserved for the recording of a particular predetermined category of information. The placing of information in fields imposes a data structure on the contents of a file, which makes them more readily searchable and hence retrievable. Database fields often correspond to individual elements of a particular *metadata schema*.

figural art

Art that includes depictions of human figures.

flat file

A computerized file in which the fields that make up a record are held in a single file. Files of this type tend to be relatively simple to use, but are not well suited to applications where much of the information is hierarchical and/or where multiple occurrences of fields are required. Compare *relational file*.

free text

Text in natural language, typically unstructured and used for description and display. Compare *controlled vocabulary*.

genre scene

A visual representation that depicts a scene from everyday life.

granularity

The level of detail at which an information object or resource is described or displayed.

hierarchical relationship

The relationship between broader and narrower concepts in a thesaurus or information system. Hierarchical relationships may be whole/part, where all linked entities are part of the whole (for example, *Cádiz, Granada, Málaga,* and *Sevilla* are all part of *Andalucía*), or genus/species, where all links represent entities that are a type of the original entity (for example, *Adirondack chairs, bergères,* and *great chairs* are all types of *armchairs*).

iconography

The description, classification, analysis, and interpretation of visual subject matter in works of art. Also, the imagery used to depict a particular subject, including its symbolic meaning. Compare *of-ness*.

iconology

The description, classification, or analysis of meaning or symbolism in the visual arts that takes into account the tradition of pictorial motifs and their historical, cultural, and social meanings. Compare *about-ness*.

indexing

The human computerized process of making a list of terms, names, dates, and other data that are stored in a structured data file and used to enhance access to full information on a given concept or topic. Indexing terms represent the most salient information necessary to retrieve the record; they are often taken from a *controlled vocabulary*.

information object

A digital item or group of items, regardless of type or format, referred to as a unit that a computer can address or manipulate as a single object.

keyword

A word or phrase that can be used as a search term in querying an online resource.

keyword searching

Searching in an automated environment using individual terms or combinations of words, terms, or component parts of multiword phrases, often with the implementation of *Boolean operators*. Keyword searching contrasts with *exact matching*, which is a search technique that seeks phrases that match the user's query word for word, maintaining the original order, and sometimes the punctuation and capitalization of words. In retrieval of Web pages or other documents outside a database, an algorithm is often developed to locate keywords in texts.

metadata

Literally, "data about data" or data categories. Metadata can include data associated with either an information system or an information object for purposes of description, administration, legal require-ments, technical functionality, use and usage, and preservation. The present volume focuses on *descriptive metadata*.

metadata mapping

A formal identification of equivalent or nearly equivalent metadata elements or groups of metadata elements within different metadata schemas, carried out to facilitate *semantic interoperability*. Also known as *field mapping*.

metadata schema (plural *schemas, schemata*)

A set of rules for recording or encoding information that supports a specific metadata element set.

narrative

Subject matter that refers to a story or sequence of events.

nonrepeating field

A field in a database that can have only one occurrence, and hence only one data value—for example, the field for the unique identification number of a work of art. Compare *repeating field*.

nonrepresentational art (*also called* nonfigurative art, nonobjective art)

Art that presents a visual form with no specific reference to anything outside itself.

normalization

The removal of punctuation, capitalization, and diacritics in the data targeted for retrieval and in the words or text typed by a user in a query.

object

In the context of this publication, *object* refers to an artwork or other museum object, a work of architecture, an archival document, or an archaeological artifact.

of-ness

An expression used in the context of subject description to refer to what a work of art depicts. *Of-ness* may also include a specific identification, as well as a generic description, of what is depicted in a work of art. This expression corresponds to Erwin Panofsky's *identification* and *description,* the first two levels of subject description outlined in *Categories for the Description of Works of Art*. For example, "The artwork is of a woman with snakes for hair" (*description*). "The artwork is of the gorgon Medusa, the creature in classical mythology who turned her beholders to stone" (*identification*). Compare *about-ness*.

optional fields (*or* optional metadata elements, optional categories)

Categories of information that complement *required or core fields;* when these fields are provided, a fuller, more detailed description or record is achieved.

Panofsky, Erwin

German-born American art historian (1892–1968) best known as a scholar of late medieval and Renaissance art of Northern Europe and Italy, and also known for having developed theories regarding iconography.

precision

In database searching, a measure of the effectiveness of retrieval expressed as the ratio of relevant items retrieved in response to a specific query to the total number retrieved. Compare *recall*. High precision indicates that from all the items retrieved by a query, a large proportion was relevant to the search. Precision in a search yields more accurate results.

preferred term (*also called* preferred name, descriptor)
A term or phrase that is flagged and may be used consistently to represent a particular concept or entity in records. In many systems, the preferred term is what appears in displays, while variant or nonpreferred terms are used as *access points* "behind the scenes." When cataloguing policy or technical limitations (for example, the lack of a linked authority) require that all variations of a word or name be cross-referenced to one and only one term or name, the preferred term is given favor. In such systems, users must look for the concept or entity under that preferred form if they wish to find all the related information available in the database.

recall
In database searching, a measure of the effectiveness of retrieval expressed as the ratio of the total number of relevant entries or documents in a given database to the number of relevant entries or documents retrieved in response to a specific query. Compare *precision*. High recall indicates that a large number of all the items that were possibly relevant to a query were retrieved. Recall in a search yields a greater number of results.

record
A coherent set of data elements or fields in a computerized file. The term "record" may also be used to refer to a coherent intellectual concept (for example, the concept of "person" or "object").

relational file
A computerized file in which the fields that combine to make up a record are held in a number of different files or tables. This type of structure is well suited to applications that require the ability to relate and combine pieces of information held in a number of files for both search and retrieval. In a relational structure, any hierarchical or other relationships between elements of records can be modeled explicitly and reproduced in the structure. (In a *flat file*, these relationships are implicit.)

relationships
Links between terms in a given record or between records, often stored in relational tables (*a relational file structure*).

repeating field
A field that may occur more than once in a record, with different data values in the different occurrences. For example, the field corresponding to an artist's life role could repeat with different values, such as *sculptor, painter, printmaker,* and so on. Compare *nonrepeating field.*

representational art (*also called* figurative art, objective art)
Art that portrays, even if in altered or distorted form, things that can be perceived in the visual world.

required field (*also called* core field, core category)
A database field or category of data that is part of the minimum set of information necessary to describe and retrieve information about an object or concept.

retrieval
The process of finding information in an automated environment, typically by using two main techniques: (1) matching words or phrases in the query against the database index (*searching*) and (2) traversing the database with the aid of hypertext or hypermedia links (*navigating*). The retrievability of information is determined to a large extent by the care taken to make it accessible by using such tools as data standards, vocabularies, and the design of the data structure of the particular information system.

search engine
A computer program that allows users to search information resources. In the context of the World Wide Web, search engines enable users to search large indexes of Web pages generated by an automated Web crawler or spider.

semantic interoperability
The ability to search for digital information across heterogeneous distributed databases whose metadata schemas have been mapped to one another.

sight size (*also called* sight measurement)
The dimensions of an object based upon the area that is visible. *Sight size* is most often used with framed paintings or works of art on paper to refer to the dimensions of the area visible within the window of the frame or mat, as distinguished from measurements taken of the entire canvas, panel, or piece of paper that forms the support of the object.

structured vocabulary
A type of controlled vocabulary in which words, phrases, or other terminology are structured to show relationships between terms and concepts. The primary functions of a structured vocabulary are to provide context for the terms and to allow better retrieval in information systems.

subject (*also* subject matter)

As defined in *Categories for the Description of Works of Art,* the subject matter of a work of art (sometimes referred to as its *content*) is the narrative, iconic, or nonobjective meaning conveyed by an abstract or a figurative composition. It is that depicted in and by a work of art. *Subject* may also be interpreted as the function or object type of an object or work of architecture that otherwise has no narrative content. Compare *about-ness, iconography, iconology,* and *of-ness.*

subject access

The process of providing or finding information about an artwork or other object by means of its subject—that is, what is portrayed in or on the object.

subject analysis

The interpretational process by which a work of art or its surrogate image is analyzed and explicit subject data or access points are created for the record representing the work.

subject heading

A word or phrase assigned in a descriptive metadata record to indicate a subject of a work, which serves as an *access point* in a catalogue, index, or database search. Broad subject headings may have narrower subdivisions, which are often concatenated to create more specific descriptors (for example, *Islamic Art—India—Exhibitions*).

syndetic structure

A structure in a *controlled vocabulary* in which logical and semantic relationships between descriptors or headings (for example, *broader term, narrower term, related term*) are explicitly indicated.

thesaurus

A *structured vocabulary* made up of names, words, and other information, typically including synonyms and/or hierarchical relationships for the purpose of cross-referencing in order to organize a collection of concepts for reference and retrieval. Standards for thesaurus construction are the *Guidelines for the Construction, Format, and Management of Monolingual Thesauri: An American National Standard,* ANSI/NISO Z39.19-1993 (R1998), from the National Information Standards Organization; and the related *Documentation—Guidelines for the Establishment and Development of Monolingual Thesauri,* 2d ed., ISO 2788, dated 1 January 1986, from the International Organization for Standardization.

typology

Classification based on a comparative analysis of structural or other characteristics.

variant (*also called* variant term, variant name)

A nonpreferred term or name that has an *equivalency relationship* to the *preferred term* or *descriptor.*

visual document (*also called* surrogate image, visual surrogate)

A photograph, slide, digital image file, or other reproduction of a work of art.

Selected Bibliography

Alexander, Kirk. "The Visualization of Art History: The Role of the Database in Visual Thinking." *Visual Resources* 13, nos. 3–4 (1998): 285–97

Angeles, Michael. "Information Organization and Information Use of Visual Resources Collections." *Visual Resources Association Bulletin* 25, no. 3 (1998): 51–58.

Baca, Murtha. "Evaluating the Use of Controlled Vocabularies on the VISION Project." *Visual Resources Association Bulletin* 27, no. 1 (2000): 44–49.

———. "A Picture Is Worth a Thousand Words: Metadata for Art Objects and Their Visual Surrogates." In Wayne Jones, Judith R. Ahronheim, and Josephine Crawford, eds., *Cataloging the Web: Metadata, AACR, and Marc21*. Lanham, Md.: Scarecrow, 2001.

———, ed. *Introduction to Metadata: Pathways to Digital Information*. Los Angeles: Getty Information Institute, 1998. Version 2.0 available only on the World Wide Web at <http://www.getty.edu/research/institute/standards/intrometadata>.

Bates, Marcia J. "How to Use Controlled Vocabularies More Effectively in Online Searching." *Online* 12, no. 6 (1988): 45–56.

———. "Learning about the Information Seeking of Interdisciplinary Scholars and Students." *Library Trends* 45, no. 2 (1996): 155–64.

Bates, Marcia J., Deborah N. Wilde, and Susan Siegfried. "An Analysis of Search Terminology Used by Humanities Scholars: The Getty Online Searching Project Report Number 1." *Library Quarterly* 63, no. 1 (1993): 1–39.

Beebe, Caroline. "Image Indexing for Multiple Needs." *Art Documentation* 19, no. 2 (2000): 16–21.

Bell, Lesley Ann. "Gaining Access to Visual Information: Theory, Analysis, and Practice of Determining Subjects—A Review of the Literature with Descriptive Abstracts." *Art Documentation* 13, no. 2 (1994): 89–94.

Bradfield, Valerie. "Slides and Their Users: Thoughts Following a Survey of Some Slide Collections in Britain." *Art Libraries Journal* 2, no. 3 (1977): 4–21.

Chamis, Alice Yanosko. *Vocabulary Control and Search Strategies in Online Searching*. New York: Greenwood, 1991.

Dempsey, Lorcan, and Rachel Heery. "Metadata: A Current View of Practice and Issues." *Journal of Documentation* 54, no. 2 (1998): 145–72.

Evans, Hilary. *The Art of Picture Research: A Guide to Current Practice, Procedure, Techniques and Resources*. Newton Abbot, England: David & Charles, 1979.

———. *Picture Librarianship*. New York: K. G. Saur, 1980.

Fidel, Raya. "Who Needs Controlled Vocabulary?" *Special Libraries* 83, no. 1 (1992): 1–9.

Fidel, Raya, Trudi Bellardo Hahn, Edie M. Rasmussen, and Philip J. Smith, eds. *Challenges in Indexing Electronic Text and Images*. Medford, N.J.: published for the American Society for Information Science by Learned Information, 1994.

Forsyth, David A., et al. "Finding Pictures of Objects in Large Collections of Images." In P. Bryan Heidorn and Beth Sandore, eds., *Digital Image Access and Retrieval*. Urbana: Graduate School of Library and Information Science, University of Illinois at Urbana-Champaign, 1997.

Fox, Michael J., and Peter L. Wilkerson. *Introduction to Archival Organization and Description: Access to Cultural Heritage*. Los Angeles: Getty Information Institute, 1998. Also available on the World Wide Web at <http://www.getty.edu/research/institute/standards/introarchives>.

Gordon, Catherine. "Patterns and Benefits of Subject Enquiry in an ICONCLASS Database (Abstract)." *Visual Resources Association Bulletin* 23, no. 2 (1996): 22.

Greenberg, Jane. "Intellectual Control of Visual Archives: A Comparison between the *Art & Architecture Thesaurus* and the *Library of Congress Thesaurus for Graphic Materials*." *Cataloging and Classification Quarterly* 16, no. 1 (1993): 85–117.

Haber, Ralph Norman. "How We Remember What We See." *Scientific American*, May 1970, 104–12.

Harpring, Patricia. "Can Flexibility and Consistency Coexist? Issues in Indexing, Mapping, and Displaying Museum Information." *Spectra* 26, no. 1 (1999): 33–35.

———. "The Role of Metadata Standards in Mapping Art Information: The Visual Resources Perspective." *Visual Resources Association Bulletin* 27, no. 4 (2000): 71–76.

Harrison, Helen P., ed. *Picture Librarianship*. Phoenix: Oryx, 1981.

Hourihane, Colum. *Subject Classification for Visual Collections: An Inventory of Some of the Principal Systems Applied to Content Description in Images*. Visual Resources Association Special Bulletin, no. 12. Columbus, Ohio: Visual Resources Association, 1999.

Hutchins, W. J. "The Concept of 'Aboutness' in Subject Indexing." In Karen Sparck Jones and Peter Willett, eds., *Readings in Information Retrieval*. San Francisco: Morgan Kaufmann, 1997.

Jörgensen, Corinne. "Indexing Images: Testing an Image Description Template." *Proceedings of the American Society for Information Science Annual Meeting* 33 (1996): 209–13. Also available on the World Wide Web at <http://www.asis.org/annual-96/ElectronicProceedings/jorgensen.html>.

———, ed. "Perspectives on Image Access: Bridging Multiple Needs and Multiple Perspectives." *Journal of the American Society for Information Science and Technology* 52, no. 11 (2001): 905–79.

Lancaster, F. Wilfrid. *Vocabulary Control for Information Retrieval*. 2d ed. Arlington, Va.: Information Resources Press, 1986.

Lanzi, Elisa, ed. *Introduction to Vocabularies: Enhancing Access to Cultural Heritage Information*. Los Angeles: Getty Information Institute, 1998. Updated version available on the World Wide Web at <http://www.getty.edu/research/institute/vocabulary/introvocabs>.

Lesk, Michael. *The Seven Ages of Information Retrieval*. UDT Occasional Paper, no. 5 (latest revision: 17 June 1995). Available on the World Wide Web at <http://www.ifla.org/VI/5/op/udtop5/udtop5.htm>.

Leung, C. H. C., D. Hibler, and N. Mwara. "Picture Retrieval by Content Description." *Journal of Information Science* 18, no. 2 (1992): 111–19.

Liu, Jian. *Meta Search Engines*. February 2001. Available on the World Wide Web at <http://www.indiana.edu/~librcsd/search>.

Lucker, Amy. "The Right Words, Controlled Vocabulary and Standards (An Editorial)." *Art Documentation* 7, no. 1 (1988): 19–20.

MacNeil, Heather. "Metadata Strategies and Archival Description: Comparing Apples to Oranges." *Archivaria* 39 (1995): 22–32.

Markey, Karen. "Access to Iconographical Research Collections." *Library Trends* 37, no. 2 (1988): 154–74.

———. *Subject Access to Visual Resources Collections: A Model for Computer Construction of Thematic Catalogues*. New York: Greenwood, 1986.

McRae, Linda. "Indexing Images for Subject Access: Controlled Vocabularies in the VISION Project." *Art Documentation* 19, no. 2 (2000): 4–9.

———. "More than MARC: Developing a Standard Descriptive Terminology for Visual Image Collections." *Visual Resources Association Bulletin* 19, no. 1 (1992): 25–27.

Ornager, Susanne. "Image Retrieval: Theoretical Analysis and Empirical User Studies on Accessing Information in Images." *Proceedings of the American Society for Information Science Annual Meeting* 34 (1997): 202–11.

Panofsky, Erwin. *Meaning in the Visual Arts: Papers in and on Art History*. Garden City, N.Y.: Doubleday, 1955.

Petersen, Toni. "Subject Control in Visual Collections." *Art Documentation* 7, no. 4 (1988): 131–35.

Porter, Vicki, and Robin Thornes. *A Guide to the Description of Architectural Drawings*. Boston: G. K. Hall, 1994. Updated version available on the World Wide Web at <http://www.getty.edu/research/institute/standards/fda>.

Rhyne, Charles S. "Images as Evidence in Art History and Related Disciplines." *Visual Resources Association Bulletin* 25, no. 1 (1998): 58–66.

Roberts, Helene E. "'Do You Have Any Pictures of ——— ?': Subject Access to Works of Art in Visual Collections and Book Reproductions." *Art Documentation* 7, no. 3 (1988): 87–90.

———. "The Image Library." *Art Libraries Journal* 3, no. 4 (1978): 25–32.

———. "A Picture Is Worth a Thousand Words: Art Indexing in Electronic Databases." *Journal of the American Society for Information Science and Technology* 52, no. 11 (2001): 911–16.

———. "The Visual Document." *Art Libraries Journal* 13, no. 2 (1988): 5–8.

———, ed. *Encyclopedia of Comparative Iconography: Themes Depicted in Works of Art*. 2 vols. Chicago: Fitzroy Dearborn, 1998.

Schmitt, Marilyn, ed. *Object, Image, Inquiry: The Art Historian at Work*. Santa Monica, Calif.: Getty Art History Information Program, 1988.

Seloff, Gary A. "Automated Access to the NASA-JSC Image Archives." *Library Trends* 38, no. 4 (1990): 682–96.

Shatford, Sara. "Analyzing the Subject of a Picture: A Theoretical Approach." *Cataloging and Classification Quarterly* 6, no. 3 (1986): 39–62.

———. "Describing a Picture: A Thousand Words Are Seldom Cost Effective." *Cataloging and Classification Quarterly* 4, no. 4 (1984): 13–30.

Stahl, Joan. "Online, Virtual, E-Mail, Digital, Real Time: The Next Generation of Reference Services." *Art Documentation* 20, no. 1 (2001): 26–30.

Stam, Deirdre C. "Tracking Art Historians: On Information Needs and Information-Seeking Behaviour." *Art Libraries Journal* 14, no. 3 (1989): 13–16.

Straten, Roelof van. *An Introduction to Iconography.* Translated by Patricia de Man. Rev. English ed. Yverdon, Switzerland: Gordon & Breach, 1994.

Sunderland, John. "Image Collections: Librarians, Users and Their Needs." *Art Libraries Journal* 7, no. 2 (1982): 41–49.

Turner, James M. "Subject Access to Pictures: Considerations in the Surrogation and Indexing of Visual Documents for Storage and Retrieval." *Visual Resources* 9, no. 3 (1993): 241–71.

Walch, Victoria Irons, comp. *Standards for Archival Description: A Handbook.* Chicago: Society of American Archivists, 1994. Also available on the World Wide Web at <http://www.archivists.org/catalog/stds99/index.html>.

Contributors

Murtha Baca (mbaca@getty.edu), head of the Standards Program at the Getty Research Institute, holds a Ph.D. in Art History and Italian Literature from the University of California, Los Angeles. At the Getty, her work focuses on data standards and structured vocabularies for describing and accessing information on the visual arts and architecture. "A Picture Is Worth a Thousand Words: Metadata for Art Objects and Their Visual Surrogates" in Wayne Jones, Judith R. Ahronheim, and Josephine Crawford, eds., *Cataloging the Web: Metadata, AACR, and Marc21* (2001) is her most recent publication. She teaches a graduate seminar on metadata and controlled vocabularies at the School of Information Studies of the University of California, Los Angeles.

Patricia Harpring (pharpring@getty.edu), managing editor of the Getty Vocabulary Program, holds a Ph.D. in Art History from Indiana University and an M.A. from Syracuse University's Florence Fellowship program. A specialist in medieval and Renaissance art, Harpring is the author of *The Sienese Trecento Painter Bartolo di Fredi* (1992). With Murtha Baca, she co-edited a special double issue of *Visual Resources* (1996) that was devoted to *Categories for the Description of Works of Art.* She has published many articles and taught numerous workshops and seminars on thesaurus construction and on indexing and accessing art museum and cultural heritage information.

Colum Hourihane (cph@princeton.edu), director of the Index of Christian Art at Princeton University, holds a Ph.D. in Art History from London University. His publications include *Virtue and Vice: The Personifications in the Index of Christian Art* (2000); *The Mason and His Mark: Masons' Marks in the Medieval Irish Archbishoprics of Cashel and Dublin* (2000); and *From Ireland Coming: Irish Art from the Early Christian to the Late Gothic Period and its European Context* (2001). He is currently writing *Enduring Vitality: Gothic Irish Art* for Yale University Press.

Sara Shatford Layne (slayne@library.ucla.edu) is head of the Cataloging Division at the Science and Engineering Library of the University of California, Los Angeles. She holds an M.F.A. in Drama from Stanford University and worked for nine years as a theatrical costume designer before earning a Ph.D. in Library and Information Science from the University of California, Los Angeles. She has published articles on access to images and has worked as a consultant on several image cataloguing projects. Her Ph.D. dissertation is *Modelling Relevance in Art History: Identifying Attributes that Determine the Relevance of Art Works, Images, and Primary Text to Art History Research* (1998).

Christine L. Sundt (csundt@oregon.uoregon.edu), curator and professor of visual resources at the Architecture and Allied Arts Library of the University of Oregon, Eugene, holds an M.A. in Art History from the University of Wisconsin–Madison. She has been technology editor of *Visual Resources: An International Journal of Documentation* since 1985. She has written on topics covering preservation, new technologies, and copyright in visual resources, in addition to teaching workshops and consulting. Her most recent publication is "Visual Resources" in Simon Ford, ed., *Information Sources in Art, Art History and Design* (2001).

Illustration Credits

All photographs are © J. Paul Getty Trust with the following exceptions:

Pl. 8. *Los Angeles:* image capture from <http://www.getty.edu>; © J. Paul Getty Trust. *Madrid:* scanned from Gabriele Finaldi, ed., *Orazio Gentileschi at the Court of Charles I,* exh. cat. (London: National Gallery, 1999), 63 (cat. no. 5); © Museo Thyssen-Bornemisza, Madrid. *Berlin:* scan of Saskia color slide no. Mif-0823; courtesy Saskia Ltd. Cultural Documentation. *Ottawa:* image capture from <http://cybermuse.gallery.ca/ng>; courtesy National Gallery of Canada, Ottawa

Fig. 7. © Estate of André Kertész

Fig. 9. © 2000 John M. Miller

Figs. 18, 19. Scala/Art Resource, New York

Fig. 20. Scanned from Gabriele Finaldi, ed., *Orazio Gentileschi at the Court of Charles I,* exh. cat. (London: National Gallery, 1999), 67 (cat. no. 7); courtesy Archivo Fotográfico del Museo de Bellas Artes de Bilbao; photo: © de la Museo de Bellas Artes de Bilbao

Fig. 21. Scanned from R. Ward Bissell, *Orazio Gentileschi and the Poetic Tradition in Caravaggesque Painting* (University Park: Pennsylvania State Univ. Press, 1981), figs. 102 (now Los Angeles; photo: Archivio Fotografico del Comune di Genova), 103 (now Madrid; photo: © Museo Thyssen-Bornemisza, Madrid), 104 (now Berlin; photo: Jörg P. Anders; courtesy Staatliche Museen zu Berlin–Preussicher Kulturbesitz, Gemäldegalerie), 105 (photo: courtesy National Gallery of Canada, Ottawa)

Percy
and the Rabbit

Written and illustrated by
Nick Butterworth

◌ Collins

Percy the Park Keeper was
in the park.
A rabbit came to see him.
Percy said, "Look at
the snow."

3

The rabbit said,
"Look at the mice.
They're playing in my house."

Percy said, "Mice!
Please don't play in
the rabbit's house."
The mice went away.

Percy dug the snow.

He dug and dug.

10

Then Percy said,
"Where's my cap?
Where's my scarf?"

The rabbit said,
"Look at your gloves!"

The rabbit said, "Look!
The mice are playing with
your things."

Percy said, "Never mind.
They *are* having a lot
of fun."

13

A storyboard

4

5

6

15

Ideas for guided reading

Learning objectives: Hearing and saying phonemes in final position; using a variety of cues to predict meaning when reading; identifying and discussing characters; exploring themes and characters through role play.

Curriculum links: Geography: The local area; Citizenship: animals and us

High frequency words: look, a, to, see, the, said, my, in, went, at, was, came, don't, play, away, where, your

Interest words: park keeper, rabbit, snow, mice, gloves

Word count: 94

Getting started

- Look at the front cover together. Ask the children if they have read any other stories about Percy the Park Keeper. Why has Percy got a spade? Read the title together.

- Walk through the book together, discussing what is happening in the pictures, pausing at p10. Ask the children what is happening. Why does Percy scold the mice? Resume the walkthrough until p13.

- Ask the children to find the words *dug, cap, scarf* on p9 and p11. How did they find them? Check that the children were able to identify the initial and final sounds.

- Look at the picture on p11. Are the gloves walking by themselves? What are Percy and the rabbit thinking?

Reading and responding

- Ask the children to read up to p13 aloud and independently. Prompt and praise correct matching of spoken and written words. Check the children use a variety of cues when reading, e.g. first and final sounds in *scarf* and *rabbit*, picture cue in *glove*, repeated word for *Percy*.

- Ask the children to discuss how the rabbit, the mice and Percy feel on p13.

- Ask the children in pairs to look at the storyboard on pp14-15, and to recap what is happening in each picture.